Covid '19
True Fictions:

Stories Before; During and After---
When Mostly Good Things Happened

by

James Andrew Freeman

To order additional copies of this book, contact:
Xlibris
844-714-8691
www.Xlibris.com
Orders@Xlibris.com

ISBN: 978-1-6641-7098-8 (sc)
ISBN: 978-1-6641-7099-5 (hc)
ISBN: 978-1-6641-7097-1 (e)

Print information available on the last page

Rev. date: 05/12/2021

Some Other Books by
James Andrew Freeman

Biblical Time Out of Mind (with Tom Gage, Cune Press, 2016)

Irish Wake Illustrated (Publish America, 2014)

Temporary Roses Dipped in Liquid Gold (Poetry, Finishing Line Press 2013)

Iris Wake: In Loving Memory of Us All (short stories, Publish America 2011)

*Liars' Tales of True Love (*sequel novel, Publish America 2007, amazon.com, bn.com)

Parade of Days (prequell novel, Xlibris, 2005, amazon.com, bn.com)

Ishi's Journey from the Center to the Edge of the World (faction novel, reissued 2006, Naturegraph Publishers, 1992, bn.com, amazon.com*)*

Never the Same River Twice (novel with Phyllis Carol Agins, Charles B. McFadden Co., 1995, bn.com, amazon. com)

Sins of the Father, Sins of the Son (stories and poems, Northwoods Press, 1997)

Death Threats, Short and Long (stories, Northwoods Press, 1994)

Broken Things, Fixed Things (poems, Dan River Press, 1988)

Hidden Agenda (stories and poems, Conservatory of American Letters, 1987)

Fever Dreams (stories and poems, Adams Press, 1985)

The Rising Cost of Getting By, Editor (anthology of poems and short stories, Northwoods Press, 1999)

The *Philadelphia Inquirer*'s former Book Editor, Frank Wilson, writing of *Ishi's Journey* as his Editor's Pick, said: *"This is a wise and wonderful book. The descriptions are lovingly precise, and the whole novel is a moving elegy for Ishi, the last wild Indian in North America, and of his vanished people. If this book doesn't sometimes make you smile and also move you to tears, then you are in need of a heart transplant."*

For Maria, Lioness of Literature and Life
Love,
Jim Freeman

Dedication

This book is dedicated to the brand new generation of Clare Karpink, Jude O'Malley and Cecelia Karpink, to the future… Someone wise once said, "She that plants trees loves others besides herself." Grow up happy, wise and caring for others, little ones. Plant some trees.

Aesop's shortest Fable :

" A Vixen sneered to a Lioness 'Why do you bear only one cub ?' "

" 'Only one but a Lion!' roared the Lioness."

Quality over Quantity ?

—

The author wishes to acknowledge the generous assistance of a 2021 Cultural Incentive Grant from the Cultural Programming Committee of Bucks County Community College. In gratitude and to support a deserving community college student there through a Foundation-registered student scholarship, Prof. Freeman will donate first year royalties from *Covid '19 True Fictions* in 2021-2022 to the Dr. Keri Barber Student Scholarship Fund, benefiting an ACT 101 community college students with demonstrated financial or disability accommodation need and who faced obstacles to college. James will again help promote this new, illustrated edition of his short story collection throughout 2021-2022; if you believe in the community college mission, and likewise believe in the good works of Bucks County Community College, please help Prof. Freeman help deserving community college students by spreading the word about this new book and its purpose to your friends and family.

The author also wishes to acknowledge Maria Mazotti-Gillan for publication of two of these new stories in her fine *Patterson Literary Review in 2013-14*: "In Loving Memory" and "Designated Early Mourner," in addition to a fi ne review of *Irish Wake...* by Dr. Stephen doCarmo of BCCC.

In Loving Memory

*"While we were being bombed in Dresden, sitting in a cellar with our arms over our heads in case the ceiling fell, one soldier said as though he were a duchess in a mansion on a cold and rainy night, 'I wonder what the poor people are doing tonight?' Nobody laughed, but we were all glad he said it. At least we were still alive! He proved it."—Kurt Vonnegut (1922-2008) from **A Man Without a Country***

The cars came in every day, and he didn't care about any of them. Cared only about normal things, like getting paid, laid, fed, things like that. Sure, Devon Schwartz worked at a prestige dealer, Kurwood Mercedes, in Doylestown, PA, in fact, but the dealership serviced not only Benzes but all sorts of upscale cars. And, besides, tragedy knows no economic lines.

It was surprising, then, that anything got to Devon, anything at all. But things sometimes did. He hated detailing cars to get them ready to sell, sharp edges to beware of everywhere, the pressure washers' incessant wet, soapy mess, constant hiss. He always went home in sopping wet metal-toed, black shoes, the summers in the dealership bays leaving his official Kurwood shirt sopping from his own sweat and overspray, the stench of engine bright chemicals, cleaners, bug remover, naptha, carnauba wax. But it was the window decals that killed him. They were, often as not, nearly impossible to remove cleanly, even after soaking to aid in lifting off the back window glass or trunk lid metal or fiberglass. But they had to go. Even the ones that killed him the most. And Devon was a hard 22-year old emotional nut to crack.

One day, just when Devon could not stand his job for one more eight hour, miserable, self-imposed day, the one that got him most came in.

It was nothing special, just an older model Chevy Malibu, maybe headed for extinction the downhill way of all GM cars in the deep crack of the 2009 recession. Not the new, cooler, body style. Probably a '05, he thought, maybe taken in trade on something better, like a new C-280 all wheel drive. One could hope.

But his thoughts were distant this oppressive summer morning, humidity building, t-storms on their way by afternoon. He was distracted by random thoughts of women, always, yet slept with himself. This day, this crappy car, he thought of Kathy Keller, that first girl, the one you thought, hoped really, would be the one. They made it a few times in high school, talked about the afterlife, that is life after Bucks County Community College, in nearby Newtown, where they'd gone to school, she for environmental science, he for police science, but he'd had too much a rebellious spirit for police study, and besides, he was book lazy, while she took to the plant and animal and planet science so strongly, wildly even, that

it led her to working salmon canneries in Alaska summers to pay for the eventual U., and to dreams of grad school…

She slept with an Italian fisherman off the Bering Sea, the Naknek River inlet, she told Devon, shattering his young dreams of fidelity and faith. And then there was the guy from Bucks County who met her in Seattle on her way back from a summer cannery shift, drove her in his Ford pickup with the camper shell to every KOA campground between there and Hazelton, up on Route 80 and 70, sleeping bagging her all the way, the crickets screaming outside the truck under moons and wind and rain. Some asshole Devon never met nor wanted to named Andrew…Devon was done with her. Their last tent-pitched battle of a fight took care of that, she telling him, "Grow the hell up, Devon, see the world," as her smarting last line forever.

So, why was Kathy in his tortured, car-detailing thoughts? And why did the crappy Malibu have to have just that decal on the back window? It wasn't like he hadn't seen similar ones before.

And there was Cheryl Briggs too, but Devon didn't want to get into that, now that there was nobody at all. Nothing but Gold Bond Powder infomercials on late night TV and nonsense controversy about Jay Leno vs. Conan vs. Letterman vs. Jimmy Fallon vs. Craig Ferguson vs. the middle America Devon had never seen, never would posit.

The Malibu was a non-descript beige, like his life, except dirtier: exactly the same but different. Several years of abuse had left their mark. But Devon was pretty good at his job for one so indifferent. He likely had ADD, but that's sometimes a blessing in life if that apt attention to everything that distracts can be organized into selectivity. The decal sticker did it for him: leapt right into his skull in a way that none of the others had. Maybe it was the white border, the grape-leaves around the border of the message in white. Maybe the damn Kathy and Cheryl or the building heat or the prospect of another lost day in the lost life of one so ready to floor his engine yet with no rear tires on the ground and no one to ride with. To camp and to sleep together with in the same bag along the highway in a camper shell. **With.** What an unfathomable word. And, anyway, his detail work half friend Ray always said, with sadistic relish: we all sleep alone. Anyone who says they don't is a liar. We can have someone next to us, Ray argued persuasively on breaks, but when asleep, we are alone. Never mind the big sleep, Ray said. There is no real **with,** he insisted once, soaked in pressurized spray prestige auto flotsam and jetsam, only **alone.**

This window sticker said some things: Ray-like existential things; put Devon back into the past and **almost with** Kathy Keller…

…Whose first fiancé' had died a fiery death behind the handlebars of a motorcycle less safe than this dull normal Malibu…who had gone on…

2

Devon stopped spraying. He wiped a wet forelock of overhanging blond hair off of his safety be-goggled lazy blue eyes, focusing, and attending to the moment…

The flowery Victorian sticker said for the entire sad world to see, "**In Loving Memory**…" But then there was Ray and a mutual break and a sandwich, made alone by Devon, and a soda, likewise packed with no one at 7 am in his bachelor's one bedroom in Doylestown Arms Apartment, $925 a month, including some utilities. "I've been thinking," Ray said in his wonderfully playful Portuguese, I-started-shaving-at-14-years-of-age way. "Maybe we should branch out past our hybrid cars. I mean," he said, "not our hybrid cars but **the** hybrid cars. There is no 'our.'"

"Course not," Devon said in the little break room, Kurwood Mercedes' official issue coveralls peeled off, revealing their mutual scrubby jeans and work shirts. "Not our anything, just the cars' names." Secretly, Devon relished the testy half-friendship with hairy Ray. The game was fun in a depressing sort of way, and "John and Kate Plus Eight" was getting tiresome, and he didn't really need that Gold Bond Powder, or did he?

The current game had started at work, with hybrid, bastard car names, but this mischievous wordplay was in his genes. Ray and Devon's early eff orts were crude but original. It started with the Benz names, out of ennui, the numbers really, the lack of names, C-300, E 350, S 500. There had to be something pithier, they reasoned while on breaks or while working. American makes had come up with some regrettable car names: the Gremlin; the Pinto; the Vega; the Rebel; the County Squire Wagon; the (lack of) Focus…and of course the regrettable "Pacer," so Ray and Devon christened the Mercedes Benz "Dreadnaught;" the Lamborghini "Insanity;" the Ford "FU-40" sports car; the "Tiguanaesque" race car, half Iguana, half tiger…

But it was Devon's Dad, Harry, who started the game, started it, before he died: the naming of future hybrid dogs. That's how it was embedded in Devon's often-inattentive-unless-he-cared genes… ***…We are all of the same,*** he'd learned, ***alone, not with,*** he knew now, ***all of us the same…***

That is why the bumper stickers he was to scrape off killed him, the window decals, the lost ones. Humor was a way to cope. ***All of us the same.***

This one killed him. This one, among the others, and there were many others, too many, in the manic, urban mid-Atlantic, this one hurt.

Devon's Pop Harry would utter, out of the blue ether, such things as "Newsflash, what do you get when you breed a Burmese Mountain Dog with a Mexican Hairless?" He'd do a literal drumroll on orange Formica kitchen countertop…buddda, buddddda, buddda, boppp…"A Burma Shave!" And he'd throw back his head and laugh, deep down to his core, as if a wounded animal freed from a fox-trap,

inviting Devon and his Mom to laugh too. But nobody else thought Devon's Dad was funny; too far ahead of his time, no doubt, too raw; too far ahead of his hybrid dog time...

And nobody at Kurwood Mercedes in Doylestown, only a mile and a half from the stately Doylestown Arms, thought Devon was funny, least of all his boss Link, named after the Mod Squad character with the fro, save that Ray and Devon's Linkster's fro was a red-haired flaming candle and Scotch/Irish origin... Yet Devon persisted, just as Harry had done before him now that his Dad was gone, telling at least one hybrid dog or animal breed name a day: almost always at lunch, told in a deliberately robotic voice as if his only slightly too few brain cells had been pickled with drugs or alcohol, as his poor Dad's had been.

*M**iss him, miss my Dad, with an ache that won't go away.***

"What do you get when you mate a Rhodesian ridgeback with a Shiatsu," Devon would lay out there, in the lunchroom air, with no fanfare, no drum roll, only the certainty of uncertainty and taxes as his metronome. "What do you call a Ridgeback and a Shiatsu?" he'd repeat.

Roadshit.

It was all roadshit.

Everything but the pain.

The pain linked him ***with*** Ray, his Dad, his Mom, even the carrot-topped Link, who, in rare moments, could be almost human, although never on summer Mondays with grubby cars stacked up in line like opening night Hollywood blockbuster fi lm patrons cued up to overpay for disappointment.

*The pain linked everyone, making us all the same, the great leveler...*This was Devon's epiphany.

Break over, the Malibu waited to be resold retail, or, more likely, auctioned off at one of those barn-like Saturday seedy wholesale auctions, where all unworthy cars named after animals, and the animals themselves, like horses, go when they are no longer prized, not ever ready again for show or race or even Kurwood Motor's "pre-owned" showroom. Not even Devon could make it near-new again, and he was a young professional.

"***In Loving Memory of our beloved daughter...***the ornate decal said...

...but Devon remembered reading a Gallop poll somewhere, a survey of 18-year-olds, showing that 87% of the boys, when asked what one superpower they'd rather have, ***flying*** or being ***invisible,*** decisively chose flying, while 91% of the girls, wisely, chose being invisible. Devon was, he realized, a statistical oddity: an invisible boy/ young man. And he... *Hurt.*

"***In Loving Memory of our beloved daughter Kathy...born Jan. 19, 1986...***"
Hurt.

Johnny Cash's and Nine Inch Nails' Empire of Dirt. Hurt.

4

"...Passed to a Better Place July 26, 2009...
"We will...
"Always love, and remember, you."
He could *not* peel this one off . Could not do anything he used to blithely do.
It was HER, had to be. Ford FU-40!
There would be no more of any of it.

5

Devon Schwartz fell down on the faintly oil-stained but scrubbed tiles of Kurwood Mercedes-Benz's shop floor, fell down on his knees like a tragic Greek supplicant upon hearing a blindsiding final fate from an oracle… He cried, inconsolably, for the first time in years and years, feeling his father in him, the sad passion of gallows humor rising, the old demons exorcising away. He felt more alive than dead for once, for always, going forward away from Thebes and Ray and Kurwood Mercedes and all that had come before.

Have to quit, he knew.

Have to quit it all.

There is no better antidote to pain than the truth, Devon, finally, knew.

There is no better antidote than the truth.

The following fictional story and fictional preface and afterward are for the very real Marine Jason J. Rother and his not-forgotten family.

Not Forgotten Man

Before
Preface to the Persian Gulf War, 1989

No one seemed to notice that Lance Cpl. Jeff J. Ready had been left behind after the exercise was over and the platoons had marched back to waiting trucks. On the night of August 30th, 1989, several thousand Marine troops participated in a night training exercise on the huge and desolate Twenty-nine Palms base in the California Mojave Desert. Marine Lance Cpl. Jeff Ready, at age 19, had followed the family tradition of several uncles who served before him as Marines, and was posted alone that night along the dusty main trail, helping to direct convoys during the large-scale exercise to prepare for the first Iraq invasion. Somehow, Ready's superiors allowed Jeff J. Ready to be posted alone, a violation of Marine regulations. Inexplicably, Ready was forgotten in the dessert by colleagues who were supposed to pick him up from the desolate trail where he, and others in his infantry unit from Camp Le Jeune, N.C., were directing the war game movements. After the thousands of young men were back safely in their bunks, no one seemed to notice. When Jeff Ready did not report for roll call, his commanders reportedly thought that he had been reassigned to another detail. When another whole day had passed and Ready failed to report at a second roll call, they reported him missing. When a widespread, three-day search of the desert training area failed to turn up the Infantryman, many Marine officials suspected Jeff J. Ready had gone AWOL. A Marine Corps spokesman and Lt. Col. said, "There was an obvious breakdown in the personnel reporting procedure."

Part One

Maybe this time I've strayed too far, Mama. You always warned me: "It's O.K. to wander, Jeffery, just don't wander so far away that you can't find your way back home." It's got to be 120 degrees, Mom. Humidity way less than 10 percent. I'm in the Mojave, miles and miles from my bunk at Twenty-nine Palms.

I've been teaching my men for a year now. "Know your terrain." I keep saying to all my Infantry guys from Camp Le Jeune. You know, guys I met after basic in North Carolina. But this California desert is different, Mama. Different and mean. And there's nobody from Cleveland or Minneapolis or anywhere to say, "Yes, sir, Lance Cpl. Ready." Yes, Mom. I'm all alone, and maybe it's too far.

The sons of bitches left me, Ma. Goddamn Marine Corp Murphy's Law. I'm walking on this goddamn dusty pissant trail, thinking about you and Dad and Cheryl and our little Danielle, and praying for Twenty-nine Palms' goddamn fi nest to miss me at roll call and get a truck the hell out here to this particular hell before I parboil. Marine Corps efficiency, Dad, just like you said. Semper Fi. Snafu. They must have shit for brains. Know your terrain.

The sun is intense here. The sand, even on this harder packed trail, almost pulls down on your boots it seems, wants to take you down. All around me are simmering miles of heaves of sand, boundless, bare, blurred lines and lines of sand ridges almost breaking, mirage like, waves of khaki sea. Boundless and bare. Know your terrain. It's a cross between the moon and a freakin' Frankie Avalon beach movie, but Frankie and Annette are nowhere around. Maybe they're making out in your Ford, Dad, just like Cheryl and me before Danielle was born. What did you call it, Dad? The horizontal rumba? Hooh ra! Got to think about other things, other places, other times. It's all I've got, Dad.

I'm on the goddamn moon. There's big mountains west of here, but they're too far. Last night the sun bled down crimson behind them, left this moonscape purple changing imperceptibly into black, and then more stars than I've ever seen came out to show me that you were looking at them too, but I couldn't get comfortable without you next to me, Cheryl. I haven't been comfortable since I left . Last night, I lay down right on the trail we hiked in on, watched star ad to star to star in the black above, but there were too many lumps under me, and the sand got into everything. Fell asleep right before dawn, shivering, honey, my mouth already feeling like it was full of black salve poultice.

The sun woke me up, baby. I'd been shivering in my uniform last I remember, Cheryl honey, lying on the ground next to my gun, wishing it were you, and then the damn sun punched up, put its fist in my face, blistering every crater and depression here on this moon, and I sweated, sweated it all. You know what it is like when you or the baby has a fever and you wake up drenched. I felt stiff, sore as hell, but I got up, pissed, not believing that I'd been shivering just twenty minutes before, and I looked around at the hot, bright side of the moon. I said, "the Jeff Ready has landed," just like Neil Armstrong. Figured you'd like that one, were you here to hear it, Cheryl. Already my mouth and throat were on fi re and I almost cursed myself for not trying to capture my urine somehow to evaporate it, like my Captain taught us here at Twenty-nine Palms. There ain't a palm within miles of here, honey. This is

where snakes come to die. The cactus than looks a hundred yards away is more like a mile. Hooh rah.

Know your terrain, Lance Cpl. Ready. The center of the base is south and west. Has to be fifteen or twenty miles, maybe more. You'd better hope for your little daughter Danielle's sake that you haven't wandered too far. Goddamn Sgt. Goddamn Marine Corp. You guys have shit for brains. Mohave Desert training in the summer! Shit for brains!

Little face, your Daddy misses you. Ohio. Minnesota. North Carolina. Southern California Desert. It's been too far. Daddy left his helmet and flak jacket after hiking for a few hours, sweetie. Threw down his backpack a little later too. They were too much weight, the things we have to carry, but Daddy would carry you anywhere and never set you down. I'd change ten-thousand dirty diapers just to be holding you. I'm carrying you with me in my mind as I walk, little face, and as the sun beats down on my ridiculous camouflage, a red flamethrower on a khaki hide drum of cloth and skin.

I left an arrow of stones for them, little face, to show them the way you and I are walking. Show them which way to go. Did Daddy go the right way for help, Danielle? Did he let them make him wander too far from home? Jesus, Sgt. Lee. Twenty-nine Palms is more than nine hundred square miles and out of our whole damn platoon you want to post me alone. War games in the Mojave, and it's 120 degrees. Semper damn Fi, Sgt. Lee. Keep humping this sand, Lance Cpl. Ready. Mouth is on fi re, teeth gritty. You're going to dry out soon. Daddy's got some water little face, but he's going to run out damn soon. Nine hundred thirty two square miles of desert base, and it's south, southwest to Highway 10. Left, right, left . Keep humping this sand trail. Watch the alligator lizards scatter before my shadow hits them. Watch the wall of blue mountains, big Nevada's distant, elusive, shimmering through heat waves, on my right. Hump this sand.

I'm coming home to you, Danielle. Just a sip from Daddy's canteen. Hot water tastes first like heaven, then sucks like a poultice at my throat. Left, right, left . I'm marching home to you. Nine hundred square miles, but whose counting now? Don't go too far little Jeff, not too far away from home.

Lance Cpl. Ready, did you read the Balzac story? Did you find the theme? Why was I instructed in these lessons? War games in the dessert before the next real thing? Another carnival of loss about to open? Yes, I remember, Miss Malvern. Enterprise High School in Cleveland. Where Mom and Dad went too when you were still in grade school Miss Malvern. Where I met Cheryl too. It's "A Passion in the Desert," right? The one by Balzac where the captured French soldier escapes and then his stolen horse dies and leaves him walking in the sand? I remember. I remember it all. That's right, Jeff, you said Miss Malvern. Tell us what happened; more importantly what you learned from it. What you took away from the story that makes it real. I remember. The Frenchman meets a panther, and she befriends him, kills

him food, leads him to water. They fall in cross-species love, real love, but become possessive. I remember that the lady panther gets enraged when the French soldier looks at a passing bird. That's the beginning of the end. Balzac says that all things are possible in the desert. The desert is God without man.

And what happened, Jeff? How did their love resolve?

Cheryl in the row behind. Sophomore year English, Fall of '81. Eyes deeper than those distant blue mountains off in the heat and simmering haze. Keep them on your right, Lance Cpl. Ready. Know your terrain.

Look at the landscape within, Miss Malvern said. Resolution of conflict leads to theme. Cheryl a row behind me the year before we began to date. Rising action. Hussein killing his ancestral neighbors. Climax not yet happening. Little face Danielle about to be. Fall of '81. Goddamn Lt. Lafer. Goddamn Sgt. Lee posting me without a partner. Without a mate. Stupid. Directing convoys I n the Mojave through the searing peak heat of day. Just damn dumb. Shiites, Baths, Sunnis, I have no stake in them. Just an oath, a promise I will not break.

I think that they might have been having sex, Miss Malvern, I said, and the snickering behind me began. That always complicated things, I thought but didn't say. Maybe they were in love, she answered. I think the panther and the soldier didn't trust each other fully, and when she snapped at him playfully, he mistook it for rage and stabbed her, almost instinctually, but really from lack of trust. It's something deep in us, jealousy, envy, possessiveness, hubris, I said. Something about holding the core of us back, never sharing all of who we are, ever. Then it was love, our teacher agreed. That's very good, Miss Malvern said. Don't you ever be afraid to search too deeply, too far, and I, red faced, sophomoric, slid back into my seat. Fall of '81.

I'm not a sophomore anymore, Miss Malvern. I'm 23. I'm humping this sand to get ready for what's to come: Iraq; Iran, maybe Afghanistan, tribal blood feuds, thousands of miles away from the Mojave but just the same. I know that some people, when thrown into a room for strangers, will look for common ground. I know that just as many others will seek differences, to other, to divide. I have been trained to keep the enemy back, away and apart, to never let him in. My enemy and the enemies of my country are who Uncle Sam tells me they are. He tells me they want to kill my wife, my daughter, freedom itself, take it all away. And we are all going somewhere to divide, sometime very soon.

But that's not what's going on here, Lance Cpl. Ready. This desert is just the first Shakespearian act. It's all about training, breaking us down and rebuilding us into a focused killing machine. Know your ass from a hole in the ground. Know your terrain better than the enemy, even if it's his home. Especially then. Blow the stranger's ass away. Your M-16 is capable, if you clean and inspect it regularly, of blowing

all of their asses away. Keep that gun on your shoulder, no matter how much it burns. Parade rest. Keep putting one booted footed foot in front of the other. Hump that sand. Cheryl and I making love or something near in the Ford. The soldier and the panther. The woods back of Enterprise High School, Summer '82. Trust me, trust me. We have more in common than differences. Love or something near.

Snafu. I'm marching home to you, Danielle. Little face, your Daddy just hopes it's not too far. A dark, milling vulture circles overhead. Heat waves everywhere.

This is about jealousy and mistrust, Lance Cpl. Ready. Jealousy between religions, nations. Hegemony. Lack of trust, emphasis of differences. Gorbachev and the Russians may be for real in allying with us, in stabilizing Afghanistan, but it's still too soon to tell, Berlin Walls fallen or not. The Middle East still has walls, is a goddamn powder keg. Damn 10/30 weight oil baron fanatics killing their neighbors and each other. What else is human history but a history of war, Miss Malvern? Know your damn terrain, and be ready to defend it from the mongrel hordes. Deadbolt the door.

But here there are no doors: just a bake oven of interior monologue, the essential Id, with vultures milling shadowed circles surreally above. A lady panther and a French soldier fell in love in the desert. It all comes down to me. Romeo, Oh Romeo…Oh, Ashley! I can think it all. In the desert, all things are possible. The desert **is** God without man…

Designated Early Mourner

He was always there, it seemed, when someone significant passed. Mid-Atlantic Hospitals. Hospices. Assisted living facilities. Rest homes. The places you'd expect. And Michael Forbes always knew them, at least tangentially: it wasn't as if he were an ambulance chaser or had any economic interest, despite what Augustine's wife had sneered once about him. That was bullshit, he knew. He just was good at death. Other people's deaths…

He'd grown up the son of a cancer doctor, had heard, and, at least second hand, seen it all. The ways the big C could end us, the many insidious ways. Michael Forbes did have a way of being there in every sense of the word. Tall, with severe blue eyes and a wild shock of black, tousled hair, he looked right into the dying ones' eyes, coming close to their souls, if eyes are windows. He, like his father, hated cigarettes.

Sometimes the eyes looking back were fading, sometimes dilated blue or black or green in fear or anger at this awful fate; sometimes the eyes and the people behind them were no longer really there. Michael always preferred those who raged against Dylan Thomas' dying of the light. The point is, or was for the victims, that Michael provided a strange comfort, not like Ellen Bursten's "Resurrection," no, but comfort nonetheless. And that was the strangeness of it, that so often Michael would be there as an ancilatory guest who became the center of the circle, the focus of pre-grief and salve, although, of course, the dying one rightly took center stage.

The scenarios were all different, Michael Forbes had thought in the beginning of his amateur calling, but later decided that they had to be, by decree, all the same, every time. Oh, they start out innocently enough, his girlfriend of the time's, Sarah's Aunt, dying of ALS and on a vent, to be removed one morning by family and lawyers' decree at 10 am, and he'd be there, the concerned, supportive guest visitor, girlfriend and 3-12 others in the room. And…

…there'd be paging on the intercom at the hospital or facility, paging Dr. Martin to Cardiology; Dr. Gophelding to anesthia. Michael had decided, early in the game, anesthia was good, in that it numbed the pain of transit, but it was not enough. That's where he came in, with those eyes of concern and comfort. He continually surprised himself that he'd never accepted money for it, his gift, of helping them go and then helping the remaining family get going on the earliest, crudest forms of mourning. It became a source of altruist's pride that he'd never gained a thing by helping others, including the poor victim, ease into the next phase of life or death.

So it was quite natural in the beginning when he held Sarah's hand and cooed in whispered breaths: "It's

all right, she will breathe on her own for a little while and then you'll see her respirations slow way down. Then they will shut off the in-room monitors and watch at the desk, and they'll tell you and you'll know when she's gone." Someone, then, had to say something or at least ask the nurses, as the air conditioner cycled off and on and the muted lights poured and retreated through the shuttered window and the machines beeped and graphs danced more slowly, retreating into themselves, like Sarah's Aunt, the newly deceased, now turning blue as the blood pooled downward into her legs and feet, gravity the ultimate heart beat when there was no longer one. Someone had to know something, Michael Forbes always thought. And he was the one who held the poor woman's last gaze and wouldn't let it go until it was gone. So it, his gift of understanding, empathetic eyes, words, questions for the nurse and doctor, began.

He didn't seek them, the endings, and at first, the word that he was good at the death bed didn't spread wide, but people did talk in hushed tones after the first one, and there were ones know one else knew about: the slumped over fisherman Michael and his Doctor father had tried unsuccessfully to revive with C.P.R. when Michael was only nine; the Grandparent gone on; the occasional open-casket viewing attended too soon, before he should have gone, the gone one looking pickled and probed, marinet-like and posed to ride forever in the ground.

There was his old boss, before Michael Forbes turned pro without a salary. He'd worked for him at a gas station and trailer rental, "Karlo's Trailer Rentals," and for his boss, Karlo, a hulking bear of man with a red mane and a big, booming, "ha, ha, HA, HA, HA" belly laugh, when he could still laugh about things, until the merciless, ozone-depleted New Jersey shore sun turned his skin and the tissue below and blood and sinew and bone and lung organ into cancer: the big C. When Michael and Karlo's son, Brian, visited the old man in the Seaside Heights Hospital, it was already almost over, but, even then, Michael Forbes knew he had a gift . Karlo's wife Beverly was there in the antiseptic room as well, with its fake Rembrandts hung on lime green walls, supposedly to cheer patients back to holistic health, and, when son Brian and Michael mumbled their muted hello's, an awkward death pending silence fell over the bright fluorescent room.

Bev broke the air with glass-shattering words that meant nothing at all but showed their love: "Come on, Karlo, you've got to do it yourself, if you want to get out of here, get up and pee by yourself." Michael remembered, even now, the tough love in the hospital air; the man, his lumbering boss, gaunt, white, two days out of massive melanoma surgery, his flimsy blue hospital gown tied in a pathetic half bow like Pollyanna's pigtail, his voice a pounded gravel resignation to death. But the old man fought his way up out of the deathbed, and Michael reached out his hand, encircling Karlo's wide wrist and the patient lumbered up awkwardly to sitting, using the bed rail arm as last locomotion. That's when he saw

18

it: that's when they all saw it: the gaping hole in Karlo's back with huge, bloody margins, the one lung left visible and membrane like and thin, pumping weakly in slow motion for the last hours, until he, Karlo, and Michael, who wouldn't let go of his boss' wrist, and wife Beverly and son Brian, all of them, knew they would never work at "Karlo's Rentals" again. While Michael's former job was nothing, just the pumping of gas and the emptying and sanitizing of trailer waste holding tanks, he missed the big boss man in the years that came. At the time, all Michael could think of to say was, "You are the best boss I've ever had," and he'd meant it, despite the fact that he'd only had a few jobs at that point. He'd wished he could do more, yet he felt wanted there, in the room for the dying, under the fluorescent lights and Rembrandt's flowers in a field.

It was never enough, Michael Forbes knew, but he also knew he had to try. It was his strange avocation. It connected Michael to people he had never even met, through those he had. Sometimes he made a difference, and that's all he or anyone can ask.

He'd come across her journal, Kathy Keller's journal, Michael Forbes had, aft er he'd held her father, Glen's, hand as he died. Kathy, Glen's daughter, was Michael's cousin Bethany's best friend; hence, it was almost natural that Michael was called in to help ease Glen's death, especially now that his focused empathy at passage points had become more widely known around around Bucks County, PA and Tom's River and Seaside Heights, New Jersey.

After Glen passed, his pallid face and features draining down, this time in a Chandler Hall Hospice, Newtown, PA warmer room, draining like his very blood flow once the respirator pressure mask was removed and the vital lines dancing on the monitors dipped down, breaths dropping to stillness and then the deep, deep sigh and then the death rattle last exhale ever, and Glen's death called officially and the monitor beepers having been turned off, Michael leading the usually silent family in a non-denominational prayer, in the long moments after, he found Kathy Keller's journal in a hospice room mini-dresser drawer, and Michael surmised that Kathy had given her Dad her private diary as a goodbye gift of love, so that, most likely, Glen could see himself in it, his immortal importance in her life and how he would live on. Michael secreted it away in his own death and dying focused Elizabeth Kubler-Ross inspired man bag of carefully chosen material, including multiple copies of Ann Morrow Lindbergh's lovely "Gift from the Sea" for the family members, he thinking that none of the already grieving family, Glen's family legacy, outside then deconstructing fresh loss with the nurses, those great nurses, saw him take it and stash it away in his transition bag. He would read it alone. He wouldn't even feel guilty, not feel guilty for his intrusion for the first time. It was how Michael Forbes knew he had almost turned unsalaried pro.

Kathy's journal said it all, how lives intersect briefly, entangle, run parallel, or in love, how Zeno's paradox of two parallel lines coming closer by a factor of two off into infinity and never crossing because half of something is always something is the perfect metaphor for love, its closeness, the growing together, the attempt to become one person, the closeness feeling like mutuality, shared purpose, no matter that lines and lives never exactly intersect. No one should be that close that they can't tell where their skin ends and the other's begins, Michael Forbes, thought, alone in his bedroom with posters of red Ferraris and a vintage Farah Fawcett bathing suit poster, prying into the tangle of father love, mother love, love and hate for Devon Schwartz, that was Kathy Keller's private diary.

I will tell only the truth here, nothing but the truth as I see it. Will suffer no lies or bullshit. Life's too short.

She's right about that, Michael thought, life's short, and he didn't feel guilty for prying into her life, the life of some guy named Devon Schwartz, Kathy's clear and present love for her father over even her mother. When life's too short you take short-cuts, he knew, avoid detours.

I thought I loved you, Devon. I did love you. We were soul mates, meant to be. So it was no one's fault. Just timing. The world. I never loved anyone more than my father, ever, until I met you, Devon, and you screwed that up. Damn your hide, as Poppy says, damn your hide.

Michael Forbes felt no quilt as he read on, the light fading outside his single window, an illuminated green Buddha ceramic lantern casting jade shadows on his bed.

Devon, my Poppy is my light, twice, three times the man you'll be but no, that's not fair to say, even here, even now. So, instead, I'll write that I love him like no other, before and after you.

As you know, he's Slavic and Finn, used to tell me, from the Slav side, "Never let them see your teeth," and "every time a Slav shows his teeth, he loses a year of his life," and the advice: "smile alone." He is stoic, strong, private, honest as the day is long. And the Finn side, besides giving us one of the hardest languages to master or even partially understand, intractable as the stars, made his still waters run deep…he rarely spoke, except at meals or in between the hard work of Pennsylvania corn farming…but when he spoke he spoke, in the English he struggled all his life to assimilate far better than I ever could with his and my mother's childhood Finnish: "ours is not to question why; ours is just to do or die" or "damn hammer;" or "Neighbor Scznieack ought to hold his peace." My favorite is his sincere, near-profanity, seldom spoken, yet pithy, prescient for real life: "Son of a buck!" I'd hide my smile until it was private, not show my teeth. "Son of a buck, my hammer is broken, now who'd have done that?" he'd exclaim, red-faced, and I hold my smile until bedtime or time to write this down alone. "Never show your teeth," Devon, unless you want them knocked down your throat…but that's

20

too harsh too, even for here...So I'll just say that restraint is not your strong suit, Devon. Neither is timing. How could you tell me that if you couldn't have me all to yourself, exclusively, selfishly, when we weren't married or anything, when we had no commitment beyond tomorrow, that you wanted all of me, all my attention, when my Dad, Glen, is already sick? How could you act like you thought you own me? I'm embarrassed for you...

Mama taught me that you shouldn't say anything unless you have something nice to say, so I'll end this for now. Maybe I'll smile in the dark tonight, run my finger over my perfectly white, bleached teeth, and not shorten my life by a year. Are you smiling in public right now, Devon? I hope so. I hope.

Michael Forbes closed the little 5" by 8", gilded, hard-covered private reverie. He went to bed and didn't show, nor feel, his teeth, riding the dream state of other people's deaths and losses, theirs sometimes becoming his own in dream mares, Kathy Keller's hidden smiles closed and hidden again in his formerly green-washed dark room, now half dark in muted moon wash. Separate threads have a way of tying together, he knew, awake and dreaming, for better or for worse, so help us God.

Michael Forbes awoke one later day after dreaming, unaccountably tired, to the sound of his ringing I-phone: "I'm Being Followed by a Moonshadow, moonshadow, moonshadow," his phone sang Cat Stevens from the seventies. He had used an "app" for that, as he'd heard kids say. He turned down the too-loud volume by rote, swung his legs over his high 2010 bedside, vintage Farrah and Ferrari streaming by in his peripheral vision, felt the cool wood floor on his bare feet, size twelve, white despite the previous summer and Jesus sandals, answering fuzzily: "Hello?"

"It's Kathy, you remember me from helping with my Dad, Glen's, passing last year...well," she stammered, this time it's me!"

Godamn this avocation. Damn my eyes. Son of a buck! Michael thought.

His green, ceramic Buddha lamp rattled as Michael paced his bedroom floor, barefoot, angry, tiring of it all. He remembered Kathy's addictive cigarette breaks outside the Chandler Hall hospice, knew how many goddamn lives smokes wasted, with their cynical CEO's multi-million dollar ad campaigns, the political contributions, the tobacco and the nicotine deaths, the 147-other-addictive-chemicals-in-there-too lobby, the way those perverse giants preyed on poor and/or uneducated people, those most likely to be addicted to the very things that would kill them, 60,000 lost ones a year in America, land of the free to chose death and the addicted. Jack and the Beanstalk Americans made bad trades for beans, for staying thin, for "relaxation," for a black and white pick-me-up in a life in insufferable shades of gray. The reasons for smoking were clear enough, desperation, lack of will power among them, weakness, sloth, brain chemistry, quick fix. But all of them were bad, Michael knew too well. This knowledge brought

him no power, no joy. Another dead smoke victim in America every 6.5 seconds.

Goddamn.

Time to get out of this strange profession, hobby, whatever-the-hell it was. Time to cut loses. Find some other way to spend quality time, rocking the cradle that leads, inevitably, remorselessly to the grave.

Yet Michael Forbes' selective omniscience, completely compatible with his third person objective, nonparticipant point-of-view, couldn't keep him away from Kathy Keller's hospice room and eventual, too-long-alosing-struggle, deathbed, and this one cost Michael dearly. Lung cancer, emphysema, asthma, Kathy suffered it all, and none of it was fair. He'd grown to hate the platitudes: "It was meant to be."

"Part of God's plan." Bullshit. It was crap. It was self-inflicted, often, yes, but it wasn't fair. And when it, the death and dying, was no one's fault, what did he say then? What was in his dying bag that mattered, that didn't dry up in his throat and float away to ether? "The Gift from the Sea," while eloquent and ephemeral, seemed to float away like a lost child's birthday balloon until it could no longer be seen, even as a red dot in an azure sky, bound for breaking aloft and then settling to earth, becoming earth. Kathy's Dad, that was one thing; it was unexpected, as it almost always is, the ending time, but Glen was older, and we equate age, life potential used up and still to go, with our losses, making them somewhat acceptable at best, or, at worst, a child dead, a baby stillborn, a stinging grief all-the-more for the years meant to be lived, the love long unlived, an aberration, a hole in your stomach and in the universe at the same time, a black hole and an ulcer, as well. Kathy's long decline haunted him in dream mares to come. Michael never forgot what she told him as he held her hand, her Mother, still grieving her husband Glen, sobbing uncontrollably, inconsolably, in her daughter Kathy's antiseptic Doylestown Hospital room. Germs can be contained, tables, fixtures scrubbed to perfection, disinfected, Michael knew. Walls can be painted bright spring colors…but none of it mattered. Unless Michael cared, and he did care, too much for his own good. Empathy stuck to him like lint on a dark cloth, winter coat. This time, Michael wished he didn't care; that he could pick the lint off and throw it away.

"It's not just how we live that matters," Kathy told him, angelic, perfect, blonde, dying, her hand stiffening in his hand, "it's also how we die."

After Kathy was gone, her diary pressed with care into her blank-faced but red-eyed Mother's cool, soft, twice grieving hands, Michael rode his bed of trembling and sweated sheets for what seemed like months of disturbed sleeps. One night, outside his now-dirty bedroom window, a bone-white crescent moon hung like a bright, clipped toenail of a deceased viewed against a dark, fathomless carpet of sky. He tossed and turned and tried to fly away like damp leaves tossed by strong Fall night winds, struggling

22

to sleep, haunted by it all, by why Kathy's Mom had never asked him how he'd gotten Kathy's private diary, by the Vietnam-era amputees he'd volunteered to help in Japan at the Army Hospital recreation center in 1969 when he was only an eight-grader, so young, seeing young men only five years older than himself, eyes gone, hands gone, legs, arms, stumps, a nightmare of nightmares, they looking forward only to stateside rehab hospitals like Valley Forge and fractured lives, if Michael slept at all. He did sleep, finally that night, sometime before the muted light of pre-sun rise and the bright, red and yellow butt crack of dawn.

Moonshadow, moonshadow, I'm being followed by a moonshadow, leapin' and hopping on a moonshadow...Cat Stevens is singing in my dream.

"I googled you, found your website, that you assist in dying for free. I'm Devon Schwartz. I, ahh, I detail cars. I called your cousin Bethany, she said you were there, this voice says in a rush of fuzzy words. Moonshadow, moonshadow, and the dawn ruins it. Devon Schwartz ruins it, the dream, the nightmare, the sleep.

Goodamn I-phone. Is there an app for peace, contentment, solace, patria, the home place comfort zone?

The moon and its shadow are gone. Farrah Fawcett is gone. Michael Jackson too. Sarah's Aunt, the first one, Karlo, his boss, Dylan Thomas, Glen, Kathy's father, some of the young men amputees from Japan, no doubt, too, how close the degrees of separation, the dying and the dead? How close, yet remote as distant starlight years: cousins, lovers, spouses, children, our DNA wanting to live on forever, us wanting to leave our marks on cave walls, our hand prints saying we were here; we had hands and eyes and ears. Michael's parents gone. His caring too?

"How can I help you?" he mustered, flotsam and jetsam of tangled bed sheets wrapping him up as he yet again crawled awkwardly from the ride of his bed, light leaking in everywhere around the edges, past his room darkening shades, now pulled uselessly shut. "Can I help you?" *It's too much, too much.*

"Bethany told me about Kathy, ahh, you were there, right? I couldn't take the decals, you know, ahh, the memoriam ones…I had to quit, when I saw her Mom's car and its decal come in. I couldn't do it anymore!" the disembodied voice pleaded for information. "You were there, right? You know… know what happened…" Michael Forbes ended the call, stood in his blue boxer shorts among strewn and rumbled clothes, a sinus headache pressing against his skull. He went to his bedroom window, his place of comfort, snapped open the dark blinds, that bright crack of dawn putting its fists in his eyes without malice, without kindness, without empathy, just is, being just what it is, as truth is wont to be, simple, sad truth, light. He kissed his poster of Farrah, on the worn spot near her dead eyes, just as he had kissed the fictional mouse in a circle of his lip prints every night with his now-departed Mother, as she'd read him Margaret Wise Brown's "Goodnight Moon," the mouse kiss cluster sleeping on paper, on cellulose, before the permanent sleep of too many good and bad nights to reckon and the final countdown to carbon atoms, to dust and ash, to earth, hurtling through space.

I have to hang on.

Michael Forbes would call the kid, Devon, back, he knew. Michael knew he had to do it, do the right thing. He just couldn't do it this day, not this day. He had to sleep on it all. Michael went back to bed, pulled his light darkening blinds back shut against the bright, but did not sleep. There would be time enough for that, he knew. Time to live. Time to die. Time to wonder, when or if, anyone would mourn his passing, anyone at all.

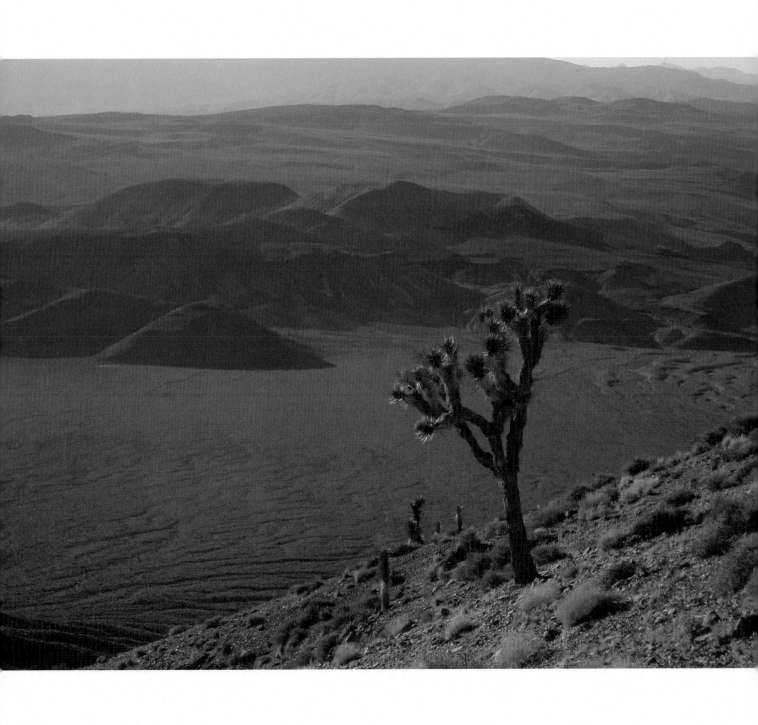

Not Forgotten Man, Part Two

Will you marry me, Cheryl? We'll take the Ford up to Niagara Falls, check into a hotel and screw like bunnies, maybe even come out at night to see the Falls pouring massively under primary-colored lights. Love and so much more. What we're fighting for? Yes, you say Romeo, Romeo. Who needs Ashley when you've got Rhett? We'll all trust each other implicitly, Cheryl, never hold back at all. In the desert, all things are possible.

Honey, it all started when we mustered on the morning of Aug. 30. All of Sgt. Lee's platoon, mostly Infantry guys shipped here with me from Camp Le Jeune, got orders for war training out on the edge of base for the afternoon. My squad leader, Sgt. Turk, put us in one truck after lunch, told me I'd be posted alone along the dirt track to help direct troop movement after the other platoons and squads got out of the trucks and marched into the site. He said I got off easy. Piece of cake.

Cheryl, honey, that damn chipped beef on bread was the last thing I've had. Got to hump these waves of sand the hell out of here. Snafu. Shoot the hell out of anything that moves. Panther or no panther, Balzac. All's fair in love and whatever the hell this is…

So Ben Mather and me, my black buddy I wrote you about, were just riding along with the others in the back of our squad's truck, dust swirling all around us and Ben's walkman blaring out his ears yesterday afternoon. Ben's from Alabama, honey, and he's funnier than hell. Always coming out with one liners. So our squad's bouncing along in a dusty column of green trucks, close to a thousand of us in our platoon, rocking to Ben's music, and he's pretending to be a black swami, coming out with fortune cookie wisdom and all. I tell him about us again, Cheryl, about Dad's car and Niagara Falls, then baby Danielle, and joining up for God and country and all. Out of the blue, in the heat and the dust and the two green roiling rows of our squad, this big damn swami says, "Marriage is where you go from swearing to love someone to loving to swear at them!"

I tell Ben, honey, I mean desert swami Mather, about Sgt. Turk chewing my ass the day before and how I want to nail gun his butt to the floor and Ben says in swami Alabama: "The hardest part of a threat is having to carry it out." Then he put a big hand to his forehead, pushes back his cap like he's coming on with another one. "The bitch about being humble is that you can't brag about it."

You had to be there, honey, had to see that big baby face strain to look both menacing and wise. Ben goes about 250, Cheryl, and here he is sitting with his open palms pressed together like Buddha, a great big smile busting out across his face. It looked so weird to see him act like that, what with all that

desert camouflage on and all the others smirking, talking trash at him. You had to be there, Cheryl.

I asked Ben if he ever gets tired of all that prejudice shit in the south; you know, sometimes they still find a black man washed up dead on a river bank, shit like that. Swami Ben tells me that there's still hate in the deep south, just like everywhere, just like maybe in Iraq, then he falls silent for a while, as the truck bounces along, swallowing dust from trucks a mile ahead, thinking. He looks right at me. Brown pools of eyes surrounded by the whitest white pupil. He says, all kung-fu style now, "Grasshopper, no one can make you feel inferior without your consent." You had to be there, honey. I'm telling you this guy may be a private, but he knows some shit. He's probably the nicest, most unusual dude here at Twenty-nine Palms. And like Ben always says, where the hell, exactly, are those palms?

So a different song comes on his radio now, an old one from way before we met in school. The old band called "America." Some of the squad guys had been singing, you know, guys like Vinnie Hubert, Tom Dicker, guys I told you about in letters home. So this song comes on, and Ben quits being a Marine swami guru and cranks it up, and we all look at each other like holy-shit, is this appropriate or what? It's "Horse with No Name," Cheryl honey, and we all start singing to beat the band and the noise of tires and trucks. *Been through the desert on a horse with no name... Felt good to be out of the rain.*

In the desert, you can remember your name. Cause there ain't no one for to give you no pain...
La, la, la, la, la, la, la, la.

In the desert, you can remember your name.
Cause there ain't no one for to give you no pain...

You know the one, honey. And we're all singing our lungs out in the dust and the heat, and then I'm laughing so hard that I'm crying, tears trickling down my hot, dust-covered cheeks, and it was only yesterday. Jesus, damn. Those sons-of-bitches Lee, Lafer and Turk should have missed me goddamn hours and hours ago at dawn roll-call. Semper damn Fi. What the hell is wrong with those shit heads? Where the hell were the Captains? Know your terrain, gentlemen. Personnel reports. Checks and goddamn double checks. The system, gentleman. It's bigger than all of us, remember? They should have known regulations don't allow posting a Marine alone.

After nine days in the desert sun, my skin began to turn red... The heat was hot and the nights were cold and the desert was
My only bed...
La, la, la, la, la, la, la. La, la, la, la, la.

Hooh, raah, I'm a man with no name. Those horses' asses probably don't know that they left me out here. Posted me alone. Direct Marine marching convoys from beside the trail all afternoon into evening.

Separate me from my men. Shit, the privates need me. Ben Mather can't hump in a straight line without direction. Leave me beside the goddamn trail all night after the platoons march out, ride back in trucks to Twenty-nine Palms. Goddamn war games. Checks and double checks. Where the hell was Turk to pick me up? Why didn't Lafer remember? What my name, Skip? Watch shows nineteen hours out here alone. This shit isn't supposed to happen! A day past roll call. Goddamn this heat. Hump this freakin' sand. There's heat waves everywhere, Cheryl. Sand wants to pull me down; vultures want to pick my bones clean. My throat is on fi re. Sweat even on my crotch. Got to hump this sand.

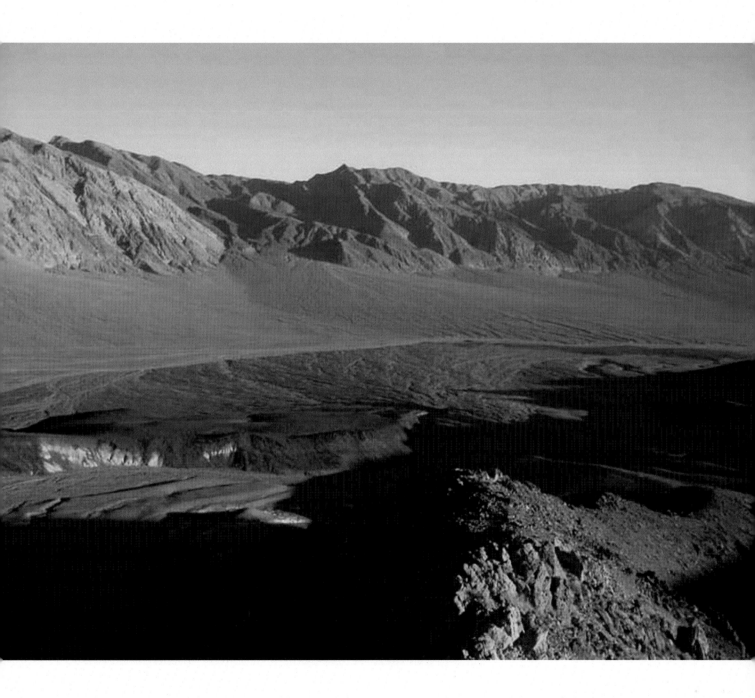

I'm in the middle of the damn Mojave, Mama. It's got to be 125 degrees. Humidity that's an absent joke. They've forgotten me, Mom, and maybe this time it's too far from home. South by southwest. Where the hell is Highway 10? A sip from my canteen to slow the fi re, the metal grommet tie-down on its khaki lid cover too hot to touch. I've still got my M-16 off my shoulder, Mom. No, don't worry it's not come to that yet, for I am young and strong and determined. Big, blue distant Nevada's on my right. Lance Cpl. Ready, if you clean and inspect your weapon every day, it will never let you down. I'm fi ring in the air, Mom. Six or seven rounds, automatic rifle butt recoiling on the top of my shoulder, pushing me down. Blowing all of their asses away. Buzzards. Tribal fueders. Trying to get heard. Maybe shooting at my own superiors. But there's no one to hear. I am emptying half of my clip into the yellow orange scorch above: punching holes in the sun. Boom, boom, boom, boom, I feel the kick again on the top of my shoulder, shell after shell up toward God, but there is no echo. No sound after the loud sound. My cap falls off backward, Momma, and, when I stop fi ring to pick it up, it's so green against the superheated yellow-tan of the sand. I can almost see individual grains, Mom, sense them rub against each other in this furnace wind. My head swims sickly as I straighten up. Taste of old chipped beef almost climbs up my parched throat. SOS. I have to have my cap. Parade rest. Right black, laced tight boot in front of left . Hooh rah, hump this sand.

We learned about poetry, Mom. Miss Malvern taught us well.

Come to the window, sweet is the night air!
Only, from the long line of spray
Where the sea meets the moon-blanch'd land,
Listen! You hear the grating roar
Of Pebbles which the waves draw back, and fling,
At their return, up the high strand,
Begin, and cease, and then again begin, With tremulous cadence slow, and bring
The eternal note of sadness in.

"Dover Beach," Mama. Matthew Arnold. Hump this sand. Grains rubbing together but each one all alone.

Man with no name. I'm all alone out here, Mom. All alone, save rattlesnakes and dark circling birds.
The ocean is a desert with its life underground, and the sea is 'made of sand...'
America, Mom, America. They have left me here alone. Miss Malvern taught us well: we are all out here alone. Left, right, left . South by southwest. Where the hell is Highway 10? Should be a ribbon

of asphalt somewhere. Another sip from my canteen to slow the fi re inside. I've got my M-16 off my shoulder, Mom. No, don't worry: it's not that. It's nine hundred and thirty-two miles of base. A place where even war games kill. Maybe Balzac had it wrong. Maybe the desert is man without God.

It's time for another arrow, Mom. Time to leave another trail marker. That's what you call farts, right Dad?

Remember all the trail markers we left hiking along the St. Croix when you came to visit me in Minneapolis? Remember how we laughed when you saw that piece in the *Twin City Register* about a mysterious St. Croix River fish kill? Come to the window, Dad, I'll meet you there. Sweet is the night air. Let the eternal note of sadness in… The ocean is a desert with it life underground. It's time for another marker.

There's another one over there. These rocks are so hot, little face. They almost sear my hands. Another and another. There's one over there, oblong, like a baked potato. Almost as hot as abandoned chrome crescent wrenches left in the August sun all day, my stones are taking shape. Another arrow, little face. Your Daddy is coming home to you for Christmas. Pointing where he went for the search party. There has to be a search party. Daddy is marking his terrain. The sun merciless, too close overhead, over the wall of shadow too far to the west.

Another rock over there. Grains and grains and mile upon mile of sand. Something moving in the periphery. Lance Cpl. Ready, know your terrain. Sting and fi re in my right leg, Sir! Spreading up my whole right side. Rattlesnake, sir, rattlesnake, my brain screams snake! Jesus, damn! Get him off, Cpl. Get him the hell off ! His off, Sir, off . My M-16 Sir, which I have inspected and cleaned, is blazing, blowing his rattled ass away. I see its muzzle flash, smell the acrid burn of powder, Sir, feel the jolting in my shoulder, but I do not hear the boom, boom, boom, Sir, and no one hears what I don't hear. I'm all alone in the Mojave, Sir. I'm the man with no name and now with little chance.

Heart pounding inside my sopping shirt, I see him there before me cut to twisting nerve fragments of tan and brown. Crotalus atrox, my enemy, all the forces conspiring to kill me, without even intending to…Nerves. It takes a long time before the pieces die. His flat, triangular head tries to propel several other inches of body forward, and I wonder where's the blood? Whether I should drink it? Rattles and several more inches of caboose-car body length also try to squirm forward in the hot sand, but fail at traction. Old, four foot buzz tail already dead, but still writhing in multiple shredded bicycle-inner-tube-tire segments on intuitional memory of Creation. Bring the eternal note of sadness in. It hurts, Dad. Hurts.

Sitting down for the first time all day, my whole body hums with adrenaline rush, and my camouflage ass sinks deep into the sand. Behind me for support, my open hands are hot stars in the sand. I feel as if a thousand pounds. My M-16 lies in the sand, uninspected, unclean. Lance Cpl. Ready, dirt is the enemy of precision. The sun is going down lower, a fierce and orange disc, too large to believe, over the line of mountains shimmering through heat waves to the west. Evening muster will be called. Roll call, roll call, please! Rattlesnake tire pieces still vibrating slowly now in the ubiquitous sand. Take inventory of my parts. Nerves tell me, too, that I am alive. But it hurts, Dad, damn it hurts.

Crouched forward now, sweat runs down my forehead into my eyes and stings them. Crouched forward, my camouflage pant-leg up, the skin of my leg looks so white, so white. Here is the nasty bite mark: two neat red puncture wounds on my right calf, just above the top of my black leather combat boot, tiny red dots an inch apart like bleeding eyes on the pale wan of my skin. So white, so white, the sun hasn't invaded here. Black hairs stand out around and in the wound. If you look closely around, you will see grains touching grains of sand. Bring the eternal note of sadness in. No longer twisting segments of rattlesnake in the sand. The boot might have saved me, Dad. Its top covers high over my ankle. Standard Marine issue. Good grade of leather dyed blacker than the blackness between the stars. If he'd hit me just three inches lower. Nine hundred thirty two square

miles of Twenty-nine Palms. If Sgt. Turk just took roll better than my ass chews gum. If and If and If. If I'd stayed at Skeen's Chevrolet in Cleveland, stayed home with Cheryl and Danielle instead of signing up. If only I'd stayed in Minneapolis, finished out the degree. Goddamn Marine Corps should know the value of each soldier. Parts are the whole. You don't ever waste even one soldier. Semper goddamn Fi. If...

You've Got a Friend in Need

It's another Saturday and Michael Forbes wakes up in the middle of a dream to the sound of grackles, those greasy, black-feathered birds, arguing, and to the sight of bright, white morning sunlight streaming through the venetian blinds. In his dream, he was on a big Triumph motorcycle, bending through the expected and unexpected curves, but now in the shower and the hot steam, he can't remember much. The doorbell rings downstairs, and Michael is reluctant to run out of the bathroom, be toweled, to answer it, because so many times in this new apartment complex it is only someone selling something to help pay their bills. He hears the bell now surely—there can be no doubt—and he remembers that Jeff and Cheryl said that they might drop in this weekend. Michael closes off the hot and cold taps, grumbles a little when the warm stream of water suddenly breaks, pulls back the blue plastic curtain, its plastic shower pole rings resisting, and steps, dripping water in foot-sized pools on cream-colored linoleum, toward the shaggy bathmat.

Wrapped tightly in his blue bath towel, Michael opens his front door. It is Jeff and Cheryl with the sunlight behind them.

"We're here," Jeff says, "as if you couldn't tell." Cheryl giggles a little. They seem very happy together, Michael thinks.

He stands there too long, blinking, a reluctant host, and they look back quizzically. Michael is long and sinewy under the towel; the muscles in the backs of his legs stand out. His chest, still mostly hairless at 34, is hard with knotted cords of muscle rope. He has a wet, black shock of hair, sticking out at crazy Dennis the Menace angles now, not yet enough empathy.

"Come on in and make me some coffee," Michael Forbes says, and Cheryl leads the way.

"What is it that we're doing?" Michael asks.

Cheryl gives him a sideways glance from the kitchen. She is so pretty Michael thinks, so full of life, younger than he. Jeff younger too and both his former neighbors. Michael catches himself wishing it could be Cheryl and him on days like this day.

"Furniture shopping, you idiot," Cheryl says, and he remembers.

Michael smiles. "That wholesale factory," Jeff says. "You wanted to look at sofas for your new place." Jeff is always reminding him of things he should know. Jeff does it out of fondness.

"How can I want to strangle a friend like that?" Michael thinks as he pads soggily upstairs. He slips behind the blue shower curtain and looks at his feet. They are almost as white as the ceramic tub, save for a

few black hairs on the tops. Michael barely hears Jeff and Cheryl talking before he turns the water back on.

Jeff's voice downstairs is muffled and sounds confidential. "You've got to understand," he tells Cheryl, "it's different for men."

Michael hears Cheryl groan.

"We're different inside than women," Jeff says. "Women are more realistic, are better prepared to deal with the real world."

"That's bullshit," Cheryl says. "He's not the first guy to have his wife run off . He's…"

"Quiet," Jeff interrupts in his soft voice, "You're always around men, but you don't see. All of us, whether we're ten years old in little league or in adulthood and all alone, think the same. We think we're jet pilots or Superman or astronauts. We think we're going to the stars, and, when something or someone stops us cold, some of us never recover. Women know how to deal with pain. They don't believe so many lies."

"Sexist," Cheryl says. "Does your velveteen box ego want some of Mike's coffee?"

"Yeah, we really believe that we can fly," Jeff says. "That we're going to fl y or glide every time we jump off a wall, cape and all. Coffee, yeah, please."

Upstairs, the wide, high-pressure Rain Forest brand shower head spray of water envelops Michael, first cold and uninviting and then warming up. He hears all of this from among the stars. He imagines Cheryl in the shower with him, them standing front to back, her long wet hair against his naked chest and belly, his life to live over, though this is sacrilege, he knows. It is 1989 and he is already gone right past compassion, aiming too high, failing to really see.

Out on the turnpike, traffic is heavy. The man high up in the helicopter on the radio tells them so as they drive in the obvious reality to look for sofas. Cheryl is talking softly about the greed and gall of Hussein in Iraq: Hubris.

"I'm all for forgiveness," she says, "but a man like that is beyond appalling. He deserves whatever trouble he gets."

"Here, here," Michael says disinterestedly from the back seat.

Jeff, driving, adds: "I'd have shot Hitler if I were around then, the Sob. Hooh rah."

A double tractor trailer truck rumbles by the little, used 1985 Honda they ride in. Jeff grips the wheel tighter as the wind vortex buffets them for a moment and then is gone with the truck.

"Shouldn't allow those damn things on the same roads," Jeff said.

Michael cracks a weak smile. "Here, here."

"Come on, Mike, must you be so goddamn depressed?" Cheryl blurts rhetorically. "After all, we are

40

helping you get some furniture."

Michael says nothing more, but he cannot be angry with her. Instead, he wants to soap her chest and belly and legs with his shower soap. He is past being angry with anyone, save his separated wife, not even angry at dictators.

Jeff changes lanes deftly to get around a station wagon in the slow lane. "Let him be," he says, "the man's got a right to be down. All we men do."

"Jackass," Cheryl says, but smiles.

The drive has been pleasant, covering subjects like the space shuttle, Iraq, Iran, foreign films, but now there is some tension. Michael feels it in his gut, despite insensitivity.

"I'm sorry," Cheryl says to Jeff, "but he's acting like such a baby." She turns around to look at Michael from the front seat. He can see her forehead and one cheek flush, but most of her pretty face is hidden by the seat and headrest. "And you," she says, turning her gaze to Jeff, "acting like it's all right for Michael to hide from life." Jeff speeds up the car. "Jesus, Cheryl," he says, "Can't we just go shopping? Jeff slows for a traffic tie-up ahead, glad for his new wife, his life, but wishing for solitude, a place to think, a healthy child.

"And you with that crap about men believing they're capable of anything in life and hurting all the more when they fall," she said, "where do you get that nonsense?" She turned off the radio. "You don't think women want it all? You don't think we want the moon? The career, Robert Redford, the grateful kids, the money? You don't think that we expect a hell of a lot more than we settle for?"

Jeff gets back in the right lane. "Here, here," he says sarcastically. "Hooh rah." He wants to be a Marine before the year is out, has already signed up. He cares.

The sun pours through the Honda's windows as they drive along, warming the interior. They are quiet for a while as the car bounces over each expansion strip.

"So were all fools," Michael Forbes finally says, "men and women."

"Jeeze, we didn't know you heard back there at your place, "Jeff says. He turns the Accord's radio back on. Tina Turner is still singing "What's Love Got to Do with It?" Cheryl turns her down. "I'm sorry she says. "We just care about you."

"I know," says Michael. "How do you put a sofa in a Honda Accord?"

Jeff, eyes trained on the road, thinks a minute, turns Tina's song down even more by rote.

"They probably deliver," he says, "or we tie it to the roof rack up top."

They are getting near the warehouse store. Taller buildings than in the suburbs shade the sun in intervals, interrupting its full-force warmth through the un-tinted windows. They are slowing down.

"Maybe we can look at the lamps, honey," Cheryl says. She has, as always, spoken her mind: she is calm.

"Yes, honey," Michael interrupts, seizing on the play of the word honey, sensing an opportunity. "I've always wanted a green ceramic lantern in the shape of Buddha, so it would keep coming back…"

Cheryl, too pretty now for words in the flashing sunlight and shadow inside their Japanese car, her hair alight and shiny, is not derailed nor detoured, ever practical. "Jeff, my real honey, how much money did you bring?" she purrs coquettishly.

Jeff shakes his head. "Not much. Spent most of it at the Ground Round last night." "I've only got a ten and my Sears card," Cheryl says.

Now Michael remembers. He feels his stomach knot. He feels more than they or anyone knows.

Jeff looks over his shoulder to make another safe lane change, all the while keeping a steady forty-five m.p.h. He is a disciplined young man. "If we find something we like," Jeff says, "can you spot us some bucks?"

Michael Forbes feels for his wallet, gets it laboriously out of his back pocket, fumbles through the folds. "Jesus," he says. He has brought only forty dollars in the wallet that was a gift from his wife. The furniture warehouse won't take his credit card, as it was a joint one, and Michael's wife has maxed it out and forwarded him the bills as a newer present.

"What's the matter, honey?" Cheryl teases, turning around again, her hair ablaze in light, eyes full of light.

Michael rolls down his back window. A rush of cool air comes in the car. Tina has long since finished singing. There is some formula rock on now, mixed with new sounds of the street, louder tire hum and the thump of crossing expansion strips on asphalt. "What *does* love have to do with it?" Michael thinks, but he is tired of thinking, feeling. He throws his wallet out the window.

Cheryl is staring backward, reporting what Michael has done so impulsively, maddeningly, purely. She and Jeff can't believe it. There is such a long line of traffic behind them, cars, trucks, even a tour bus, that it will be next to impossible to find the billfold, and Michael doesn't even seem to care.

"I take it all back," Cheryl says. Her rearward facing face wears a screwed up, eyebrows lifted, red cheeked expression of puzzlement. "Men *are* lost in comic books. No woman would throw her purse out of a car." Her hair floats upward in waves in the wind until Michael rolls his window back up tight. She is still beautiful. Jeff is angry. He drives in awkward silence nine miles to the next turnpike exit, pays the toll with loose change from his never-smoked in ashtray, and he has to count it twice to get it right. They head back the wrong way; Jeff runs the Honda hard through the gears, but there is so much traffic that it takes a long time to get to an exit before the scene of the crime.

"The Eagles" are playing through the radio in the background white noise of car horns and traffic, "A Horse with No Name," a song Jeff hasn't really listened to the lyrics of, only hummed mindlessly, but no one in the Accord is singing now. Cheryl turns off the radio as they exit again to pay. She helps Jeff

count out the dimes and pennies. It is clear to all, Michael especially, that they love each other. Michael feels a twinge of regret at continuing to covet Cheryl's hair, eyes and eyebrows…

"Pennies from Heaven," Michael says. Nobody laughs, and there is no music now. "Maybe from Hell," Michael mumbles to himself, his right butt cheek feeling better for its lack of thick wallet tilt, better than it has on any car ride in years.

Jeff thinks he has the right spot. He wears a green and tan sweater, looking military, but all Michael can see of him is the back of Jeff's head, his green and tan shoulders and a headrest. Jeff pulls the Honda off the highway onto a sandy berm and clicks on the emergency flasher lights. They tick on and off like a metronome as vehicles blast by so close, rocking the car with wind and the Doppler sound effect, over and over again. "Damn," Jeff says. He has visions of he and his two best friends in life getting creamed by some errant semi-tractor trailer rig. Jeff has to time things just right before he can open the door. The line of cars breaks for a moment, and he jumps out of the Honda, leaving Michael and Cheryl inside. Secretly, he loves being the reluctant hero; it is good training for what he knows it to come.

It is miraculous. The wallet lies in the slow lane, near the sandy shoulder, just some fifty feet ahead of the car. When Jeff scoops it up, marching fast, he sees that is has been run over a few times but seems intact. A box truck blasts by as he trots back. Jeff's soon-to-be shaved hair blows wild. Again, the fear of dying for something so absurd races through his body, but he makes it safely back to the car.

Michael looks at the tire tracks in the leather skin of his wallet as they drive toward the exit where they'd first turned around. "You didn't have to…" he says.

"Shit Michael," Jeff says, "you know how hard it is to get another driver's license and to replace those cards." Cheryl nods assent.

"Besides," she says with a smile, "what are friends for?"

Michael looks through his wallet, taking inventory. He takes out a picture of his wife. She is tanned and leggy in her bathing suit next to him in front of a generic-looking hotel in the Bahamas. It is just last summer. She is as far away now as the sofa he didn't want to buy anyway, but she is the best thing for him. When they are together, she is of earth and life as it is and not of sky and stars. In fact, Michael thinks, the only thing better than having her back would be Cheryl or a green-jade ceramic Buddha lamp. He wonders what she is doing, whom she is with, whether she has bought anything new that hasn't yet shown up on his credit card, perhaps a sofa or a lamp. Surely this same sunshine touches her too. Michael puts her picture back into its holder upside down and backwards, then shoves the whole wallet into his *front* pocket, learning always.

The little man in the toll booth is surprised to see the three of them back again at his exit so soon. He is even more surprised when Michael hands Jeff one of his twenties for the forty five cent toll, telling

the operator to keep the change. Life is full of surprises, not all of them so pleasant.

Turned around again, they drive back the wrong way toward home. Cheryl knows they need cheering up. "Think of all the money we didn't spend," she says.

She gets the radio going again and Marvin Gaye is singing "Heard It Through The Grapevine" before he died. The little Honda is still warm in the sunshine; the tires are humming smoothly, and Cheryl gets everybody to sing along. They do it right, and all three of them are teary with laughter before the inevitable commercial comes on.

"We've got over thirty dollars between us," Cheryl says. "Let's stop somewhere and get drunk. Somewhere better than the Ground Round."

"More proof that women are more practical than men," Jeff says. "We're on our way." He drives on more enthuastically.

"But to where?" Michael asks.

It is a fathomless black night with no moon and few stars and Michael hasn't thought to leave his porch light burning, so Michael has trouble getting his key in the front door lock. It is cold, he's had too many beers, and his hand shakes. He wishes he'd invited Jeff and Cheryl in instead of saying their goodbyes in the parking lot, the taillights of the Honda glowing red as they streaked away and blurred and finally disappeared as Michael stood too long and watched them get further and further away. He does not want to be alone anymore.

Inside, in the bright light, he turns the heat pump up to eighty degrees. Michael turns on the television in the living room and hears Johnny Carson in his dotage saying something about smog in Burbank, as if this is a surprise. Michael takes out the resurrected wallet from his front pocket and walks into his kitchen. He finds the backwards and upside down snapshot of he and his wife, takes it out, corrects it, puts it into his back pocket, and then throws the wallet, contents and all, into his kitchen garbage pail. The brushed aluminum trash can lid flap makes a satisfying half revolution as the wallet drops down on a half-eaten and cold pizza slice and other bachelor scraps and debris.

Back in the living room, Michael sits like Buddha on the cold floor in a spot where a sofa would fi t nicely. A ceramic lamp would brighten his night significantly too, he muses. He studies the picture of his wife in the hushed yellow overhead light dome and in the pastel colored glow of the television. In the picture, she is far better looking, smarter and kinder than he remembered. It doesn't matter, Michael thinks. She is gone for good. Perhaps he will go to the Bahamas with someone else sometime. Even better, Hawaii. Tonight he falls asleep on the cold wooden floor with all the house lights up and the television on.

"We've got a great show tonight," Johnny Carson says, but Michael begins to dream of reincarnation and other lives again.

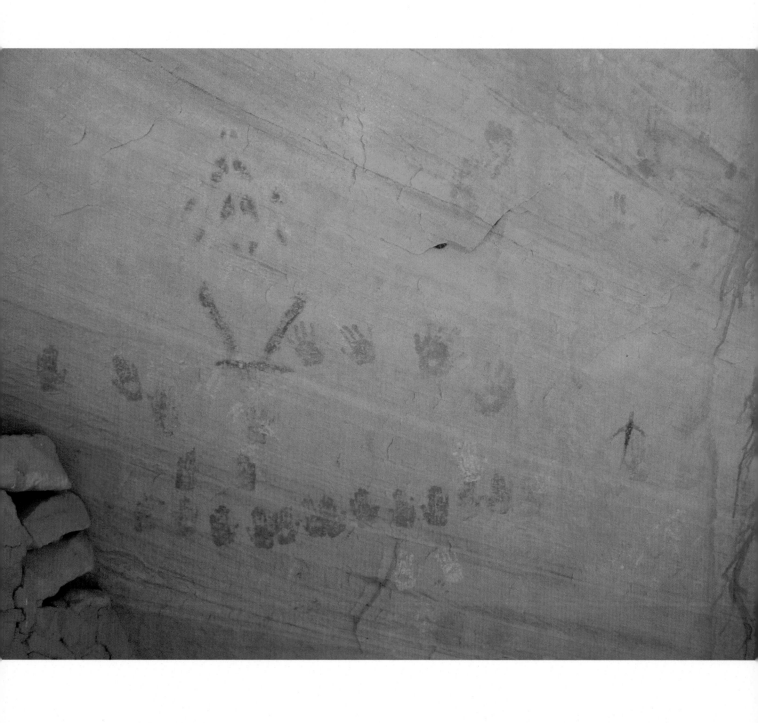

Not Forgotten Man, Part Three

The venom tastes vaguely like anise, mixed with blood and spit and sweat and sand. I try to project this spittle out, spit this toxic mixed drink as far as I can, but it lands on my combat boot. A sad conglomerate glob pools there, then slides slowly down black leather to the sand, leaving poison licorice, blood, salt and grit in my mouth like a poultice. Not John Wayne. No comic book superhero. No video game. Just the man with no name. I know that I haven't gotten it all, Nowhere near.

On my left side, waist-level, I feel for my green webbed belt, find it, look down to see my camouflage-covered canteen, then unhook its two hooks from two of the many metal-riveted holes that puncture my belt. Dad has a belt like this he wears hiking. We leave trail markers behind. Army surplus. On the water, birds' wakes are ours. Behind us, Dad, the way grows wider. The bread chunks we feed the ducks fall apart like reasons, and, water saturated, sink to the bottom, become mulm and decay. The ocean is a desert with its life underground and the perfect disguise above. I take a big dollop of my hot water, too much, and spit it far out, satisfyingly, on the sand. In an instant, dryness pulls again at my mouth, a poultice. The late sun dropping orange and crimson still blasts down in my matted hair. Canteen lovingly capped and re hung on my belt, I suck at my calf again. And again. I cannot get it all. We have to believe in something: it can't all be accident, chance. Faith is a leap away from reason to a place higher, you said, Dad. Memorized taste of chipped beef again forces up my gut when I bite into the dead twister's mid-section chunk and try to chew, crunching soft, reticulating bones, retching my own emptiness. The desert is man without God. Twenty three hours gone. Desert snake is still warm, bitter like acorns and under-cooked chicken and I cannot choke it down.

I cover up my swollen calf with desert fatigue pant-leg, cinch up my bootlaces tighter, pulling the bootlace tails so hard after retying the bows that the lace strings leave red lines underneath my fingers. A redder red fading to light pink…Even here, my skin is burning, even here. Still sitting ass inches deep in fi ne grain sand, I stretch my left leg way out, hook a snake fragment with my boot and drag it across the uneven, rocky sand. It is the head and some trailing entrails, still warm to the touch, but where is the blood? Up close in the implacable red and orange light, its head is tear-drop shape, bigger than a tan fifty-cent piece, powder-coated with lighter-colored sand. Its milk-white fangs, like sperm, Cheryl, that's it, exactly the color of sperm, lie back parallel with its upper jaw—unable to strike in death. I study his eyes: the covering membranes are drawn back in death, no more to pray. Lidless, lidless yellow eyes reflect back fierce little sapphires of crimson sun when I rotate its head. More fi re in death than any

gemstone. Still sitting, I force the head and piece of guts into my right fatigue pocket, souvenir future breakfast, thinking optimistically, postcard from home. Little face, little face, I'm coming home to you. Got to hump this sand.

Movement and hot breeze have powdered my cap with sand, but I pick it up as is and pull it tight down on my head. I feel the grit fall in my scalp. Have to protect my head. I gather up my M-16, make a half-hearted attempt to knock some of the worst grit of the stock and magazine and the end of the barrel near the upright sight and then, using the military's fi nest' s dangerous end up as a crutch, I am up, on my feet again, head swimming, lurching forward on stiff legs. Left, left, left, right, left . My lower right leg sears. I'm coming home to you, Danielle, my little face. Got to hump this sand south by southwest to Highway 10. I'm coming home to you and your Mom and Pop-pop and Grand mom. I leave my crude directional arrow, an unfinished vector of small stones. Pointing out the way. Birds' wakes are ours. Behind us, the way grows wider. Little face.

I'm dehydrated, I know. Maybe this time it is too far. Haven't had to piss all day. Bad sign, Lance Cpl. Ready. Hot side of the moon. The wicked orb of sun is dropping behind the blue line of Nevada's in the west, at least, casting horizon-long shadows in wide bands and patches over lines and miles of sand ridges freckled here and there in my close vision with Yucca brush, like seaweed flotsam and jetsam thrown up on tops of breaking sand waves, it seems to me. Small heaves of sand, painted on by broad strokes of shadow and light. It is the biggest, most terrible and beautiful land I have ever seen. I am so very, very small. A speck of camouflage barely marching to a soundless internal tune. So easy to miss in the vastness, really just a colored grain of sand. Those fiery backlit mountains, turning black now topped by blood red, are so close I can feel their coolness, yet so far I can't guess the miles. My favorite poet Bill Hotchkiss said these mountains do not cry for tragedy or smile for peace. They do not need us, do not want us, will applaud with claps of thunder when the human race is gone. God without man. I have a wallet in the right rear pocket of my fatigues. In it is a driver's license, a military I.D. card and maybe twenty bucks, but out here, in the sunset-painted desert, I am a little movement, a humbled soldier alone, a part without a whole, a man without a name. Hooh, raah. Bring the eternal note of sadness in…

A Man and a Woman

A man and a woman, an attractive woman and man, walked in Tyler State Park, PA, holding hands. They were lovers.

They came upon two Canadian geese necking and preening beside the curve of flowing Neshaminy Creek, right next to the path they walked, right by a creek side bench.

"He wants to make it again with her," the man said. "He wants to make it with her even though they've done it a thousand times before because it's never as good as the next time, the soon-to-be mating time."

She squeezed his hand tighter as they walked on in February chill, patches of snow punctuating the chaparral beside the broken trail. "They mate for life you know," she said regretfully. "Why couldn't we do that with our longtime spouses? Aren't we here, together, because we failed where these two geese succeeded? Look there, they are so in love."

The big black, white and grey birds did seem interested in each other, perhaps for the thousandth time. "They are no more in love than we're in love and maybe we're all the stronger for the fact that ours has to be stolen love right now," the man, Tim, said.

He was taller than his Kate Ann, just as the drake goose was bigger, heavier, looked down a little to see his hen Canadian goose mate. Tim squeezed her hand back. Strong.

"Ouch," she teased. "Big he man molest lady goose against her will…"

"But she seems to like it," Tim interrupted. "And, besides, it's not that way at all. See that lone bachelor swimming toward them in the water, making his big 'V' wake? Well, that's me. The other guy, the temporarily amorous one, he's your little old Mike."

They walked on past the Canadian goose pair. Walked on up the rough pavement beside the creek, under the reach of bare winter trees, parallel to the interloper honker goose.

"And I'm swimming up in cold water taking a big chance at rejection, testing your theory that geese and humans mate for life. And lookee here," Tim said, pointing at the swimming, eager Canadian goose, "look at that, would you? I am one buff goose!"

She laughed a little, coquettishly, his Kate Ann, and they walked on. The trail turned off the creek, uphill, into the muted, hushed darkness of tree shadow.

They, the humans, Kate Ann and Tim, had been lovers in their heads for years too. But only recently had they each mated for life for the second time, each of them. For the best and last time, forever it seemed as the park light faded a little softer around them under a canopy of naked trees above and frozen leaves

crunching underfoot. It had changed their lives, this second, better, lifetime mating. Changed their lives indelibly, inextricably, and sometimes frighteningly, for the better… They walked together, hand in hand.

Time passed. The light faded noticeably as the sun dipped blood red-orange between the jumbled frames of bare, gnarled upper tree branches. There was no breeze. Just absolute…stillness. Kate Ann actually heard her heart beating.

"My car's just up the hill," she said a little sadly. "Probably best, even now, for us not to be seen together in public…"

He pulled her close against his chest, wrapped her in his unzipped coat. "That sucks, I hate that," was all he could think of to say.

Sometimes, the words failed Tim.

They kissed like it might be their last good kiss, like it might be all they had to remember each other by for a long time to come, as if their deep kiss, coupled with the one and only, long and languorous and heated time of loud cum cries, when they had come together again and again out of Eros and Agape, out of love, like that one sacred time they carried together with them always, feeling the body and spirit memories of each other even now.

Tim hated to let her go.

"Give me the high sign when you're at the top of the hill, in sight of your car," he said, fighting back tears. "Then I'll let you go."

He watched her pick her way carefully up through windfall trees, moving vines to keep from tearing her clothes. All he saw was her lovely back, the one he had so loved to trace the one time he'd felt her bare skin, now covered up, jacketed, about to leave him.

Kate Ann turned, finally, flashed him a distant, shadowed, weak smile. She put her thumb up in universal sign. Then she was gone over the little treed hill beyond his view.

Tim stood watching from the screening trees, waiting. What if her car didn't start? What is she had a flat or if some stranger was waiting up above…

Then he saw her familiar Toyota cross by the road well up ahead of him, come quietly to the park intersection. He saw her put her left flasher on, turn away from him, drive away from him to the husband and teenagers who waited at home for her to cook them dinner while Tim dreamed of the Bahamas.

Tim watched her red taillights chase away to semi-darkness all around. He must have stood motionless for 10 or 15 minutes feeling his feelings, hearing sounds of the woods closing in.

He knew he'd have to hurry back to his truck to drive out before black. On his way back along the path they'd walked together, now alone, he still tasted her kiss, could feel her still.

At a place on the Neshaminy Creek where the water ran deep and slack, between two spill dams, near where they'd seen the ménage-a-tous of geese, he saw something swimming. Something big in the nearly impossible light. Can't be, he thought, but it was. A big, brown male beaver swam and dove unabashedly, the only one Tim had ever seen in 24 years of living east.

Tim couldn't resist. They were the only two mammals for many yards, after all, he land bound and tasting lingering human kisses, the beaver so obviously and completely focused on being just that very fi ne and rare beaver, impervious to the icy water and to the quixotic affairs of upright bipeds.

"Slap for me!" Tim yelled. "Give ME a sign."

And the beaver did: startled, he rolled over liquidly onto his back, gave one big flat, shovel-tailed water slap, then dove under suddenly and away, leaving only ripples and a widening water ring where he had been. It seemed to Tim that the lingering taste of Kate Ann's mouth, the feel of her body, lithesome curves remembered, lasted infinitely longer than the sound and the beaver's wake that now reverberated and bounced satisfyingly off the frozen creek side walls.

Driving home to his rented cabin, in the harsh light beams of his truck, he scared up a red fox, tinged with black accents, which ran pell-mell across the road. He caught deer eyes, those eyes of dreamers, over and over again in his shaft s of artificial light; he even heard big Vees of geese calling high above, moving on to better pickings after dark, harronking above the sound of his engine working and the Joni Mitchell "River" CD she'd given him playing now in the warm truck's cabin, filling it with beautiful, plaintive sound, but nothing mattered as much to him as the taste of her kiss, still and forever with him. Nothing else mattered. Half as much. Nothing at all.

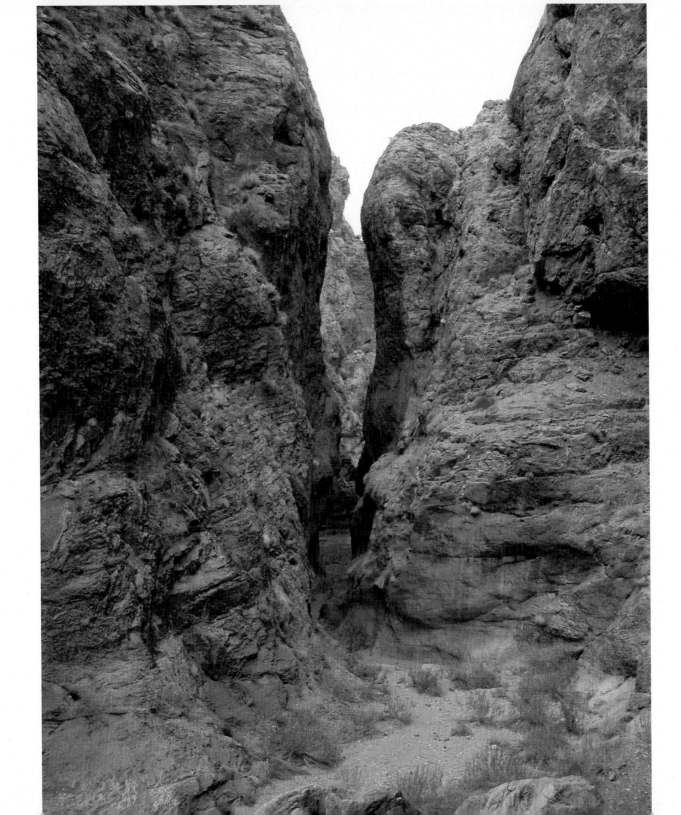

I'm cold, Dad, cold. Lying here like a sand-borne fetus, I'm covered up by my loose camouflage outer shirt, curled up in a little depression I dug out in the sand between a couple of sandstone outcroppings, but I am cold. The wind comes in from Los Angeles off the distant Pacific and over and down those invisible blue midnight peaks. Twenty six hours, Sgt. Turk. Two nights, Lee, two nights Lafer. When a swirling, cold night sirocco knocks the cap off my eyes, I see that the night above is a starry, pin-pricked dome, and I shiver. There are stars and stars beyond counting, shimmering in the vast black with indeterminable depth, like silver spray paint blasted through a sifting colander of galaxy deep underwater and sinking down in different shapes at different falling rates, ages, near and far, and then beyond sight to the bottom of the night sky. The black in the water in the vast sky above is the blackest black, broken by a million million tiny, cold silver lights. God without man. I'm tired in my bones, Dad.

Father, if you're up there behind the light, let me see little Danielle again, see my wife Cheryl. You remember me. I called on you when my baby sister Lennie had lymphoma and again a year later when Cheryl's Mom had her stroke. My old boss from the Chevy dealer died last year, God, and I didn't bother you then. You're probably up there smiling at the limit of our understanding, saying that there are no atheists in foxholes over and over to yourself. Show me the way in the morning. The way out of here. PLEASE. I don't have much time left . I'm already almost gone up to you. I'm tired to my bones. This bed is bumpy, Dad, I can't rest. Can't let go. You can take me after one more visit, Father. Just let me see them one more time, tell them how much I love them. Please. It's a cold wind that knocked my cap off . The sand is getting colder. So damn cold. Please show me the way.

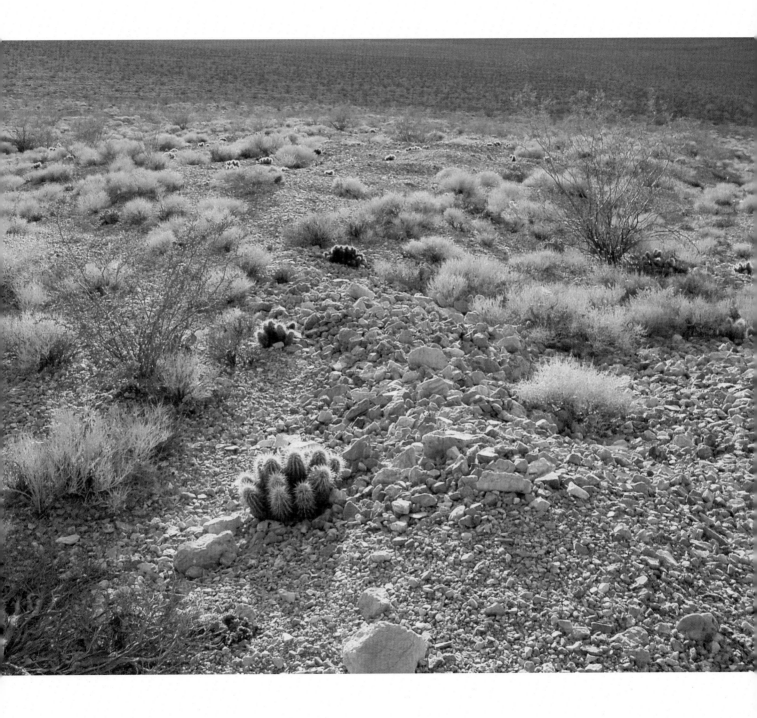

I awake deep in the astral night, shivering uncontrollably, cradling and rocking my gun, so far from the Persian Gulf, but deep in it in my waking dream. There's a bitter, abrasive grit in my chattering teeth, an awful death dryness in my mouth and seared throat, laryngeal pharoses. I am sore everywhere there are nerves, tendons, muscles, sinew, bones. The vault of countless silver stars is still above me, shimmering downward cold cold cold in black liquid sky. Implacable and cold. Still the sirocco wind and sand and moon shadow, a seventy degree temperature drop, and an awful emptiness. No reply from God. I pull my cap down tighter, roll up my camouflage cover, then drift off again. Drift so far. So far away from home. It's too far, Mother. Too damn far. There's my Dad. There's my answer! And what the hell is Ben Mather doing there in my folk's home sitting on the leather sofa next to Dad's easy chair? They've never met. A dream, Lance Cpl. Ready, a dream mare. Keep your post. Inspect and clean. But they are talking. It's like some damn scene out of "It's A Wonderful Life," only 250 pound black private Ben there on the couch is the angel Clarence, and Dad is Jimmy Stewart dressed in his robe and slippers, relaxing by the Christmas tree. I can almost smell it. Yes, Fraser Fir. Dad says you know you're getting older when it takes longer to rest than it did to get tired. Ben agrees. Dad shift s in his easy chair. You know you're aging well if the number of things you can no longer do equals the number of things you no longer want to do. Higher math, Ben agrees, still dressed in camouflage fatigues. Dad goes on, Jimmy Stewart in disguise. Being human means that you are not only entitled to make mistakes but you are also entitled to regret them. Dad goes on. Any friend of Jeff 's is a friend of mine. What the hell is Ben Mather doing here?

He's talking, Mama. Sitting in our living room. The sand is cold grit under me, the wind is swirling cold, but Private Mather, alumni of Camp Le Jeune, is talking in our Cleveland living room. He tells Dad that *The Bible* says to love both our neighbors and our enemies, Iraqis and all. That should be easy enough, Dad answers at Christmastime, because they tend to be the same people. Ben stomps his Marine booted foot, laughs his bighearted laugh from way down inside, flashing white teeth and pink gums, sending our Christmas tree jingling into a blur of tiny red and white lights that become stars in desert sky.

Dawn's up hard east, and I'm awake, still here, Cheryl honey. My tee-shirt soaked in a night sweat under my camouflage shirt. Already shifting waves of building heat jiggle the yellow mountains to the west, dance and rock the eastern panorama of sand waves and sand rolls that disappear into the jiggling limits of sight, into a blood-red ball of furnace crawling up and over yellow sand, distorted oval, stellar fi restorm of light, the limit of what I can see and know. God? My cap falls off again. Marine watch says it's a September morn., and I'm dying of dehydration, exposure, neglect. There's grit in my teeth, honey. I

taste sand in my mouth. Feel it in the matted hair on the nape of my neck. The sun in the Mojave paints harshly, honey: unforgiving palates. The sun pushes its fists into my eyes. Abraham's Old Testament God. The morning is a hundred thousand Christmas flashbulbs in a department store Santa's face after an all-night bender, Cheryl. A brown alligator lizard runs over my sore lower leg: I barely feel his splayed feet scurrying over my pant-leg over the chronic, throbbing ache. There are animals out here, honey. Last night I saw a vulture circling the moon and starlit sky. There are animals that would love to chew me down to a litter of bleached white bones. I don't think I can make it, honey. Jesus, God, don't let me die. If Abraham is myth, let me have a better, New Testament myth. Let me live, please, please.

I'm too young for this shit, God of Abraham, God of Jesus' "Sermon on the Mount." Almost twenty-four. So much more. Whole life ahead. Only memories behind. Drink some fluids, Lance Cpl. Ready. Keep your strength. I'm up again, Cheryl honey, fighting to gather my cap, my M-16, my wallet where it must have fallen out, so brown and out of place against the illuminated yellow sand. Driver's license photo. So damn zit-faced young. Military I.D. Check cashing card for Safeway. Twenty dollar bill. I scatter them all to the sand. No time for Ozymandias statues. Have to hurry. My back hurts. Right leg is numb. Have to hurry. Late for work at Skeens' Chevrolet, honey. Can't come back to bed to snuggle now. Have to hump this tenacious sand. I'm coming home to you, Cheryl, one way or another. Old Testament or New. Coming home on one leg to little face and you. I take a pull on my canteen. The water tastes like metal. As soon as it's down, want races back into my parched mouth and throat. I try another sip, find my canteen empty and throw it as far ahead as I can into the light-painted blur of sand. I am marching on one leg. I'm hungry, little face. Daddy's hungry in the yellow-orange dawn. I find the snake head cool to the touch in my right pant pocket, pull it out, trailing dried guts, with my right hand. The eyes are dull this morning, Mr. Skeens. Milky way white covers both irises. Sorry I'm so late. Rough night with the baby. Cried until dawn crept in. The eyes are so dull. Won't even fracture and reflect this intense Old Testament light when I hold the snake head up, rotate it like the Hope diamond in unforgiving jewelers' light. I take a bite of the entrails, neck if snakes had necks. I have to struggle a long time chewing through the cool skin and chords of muscle to separate body from head. Stumbling forward, ever forward, I pass my upended canteen. Random camouflage marker in yellow sand. The lump lies in my mouth, a poultice, raw jerky, sashimi rattlesnake, my demise; without him, I might have lived. I let the unholy morsel lay there, my spit coming back again drawn out by black salve, until the retching begins. I spit the whole mess out into the sand. Fling the remaining head toward the jiggling yellow Nevada's somewhere in the west. Daddy's hungry, little face, but he can't eat. I remember that Bobby Sands, the IRA hunger striker, wanting to get the British the hell out of his Ireland, said this as

his last words before dying: "The best revenge is the laughter of your grandchildren." You'll have to have your own children, Danielle. Your own little faces, my grandchildren, the family name living on.

Watch says 11 a.m. now. Eleven hundred hours, Sir. 110 degrees. Humidity way the hell down. Hours past yet another roll call. Lower right leg swollen and numb. I've come to a big sand ridge, little face. A ridge that looks capped with searing rocks. Contour relief. Maybe your Daddy is finally walking off the moon. Right leg dragging in this tenacious uphill sand. Three hard-fought steps forward in combat boots. Two steps sliding back. There's sweat stinging my own dull eyes, darkening my shirt. Salt on the backs of my sun burnt hands. The ocean is a desert with its life underground, and there's a small sea of large, scavenger birds overhead.

La, la, la, la, la, la. La, la, la, la, la.

Little girl, little precious blonde girl, Daddy's girl. I'm at the top of the ridge, kicking a little rock here with the boot toe of my good leg. It falls and falls down the far side of the ridge, gathering momentum, a miniature avalanche of sand spreading an ever wider and wider wake. I face south. South by southwest. On my left, the pulsing orb of sun is high up and dominating the world, nearly straight overhead. Below it, the scene opens up as always on its marks, on shimmering miles of heaves and retches of sand, bare line after line after line receding. Boundless and bare. On my right, the orange mountains are dancing further away to wafting haze. My head swims sickeningly. The pulse hammers in my neck. In a black cave in a canyon near Tassahara, Miss Malvern, the Indians left only white tracings of hands. Robinson Jeffers saw them there, knew that they had hands, not paws. What do you suppose it all means? Let it in. Let it in, Miss Malvern. They were here before us: before us, before us. We killed them. Let it all in: the enormity of it all.

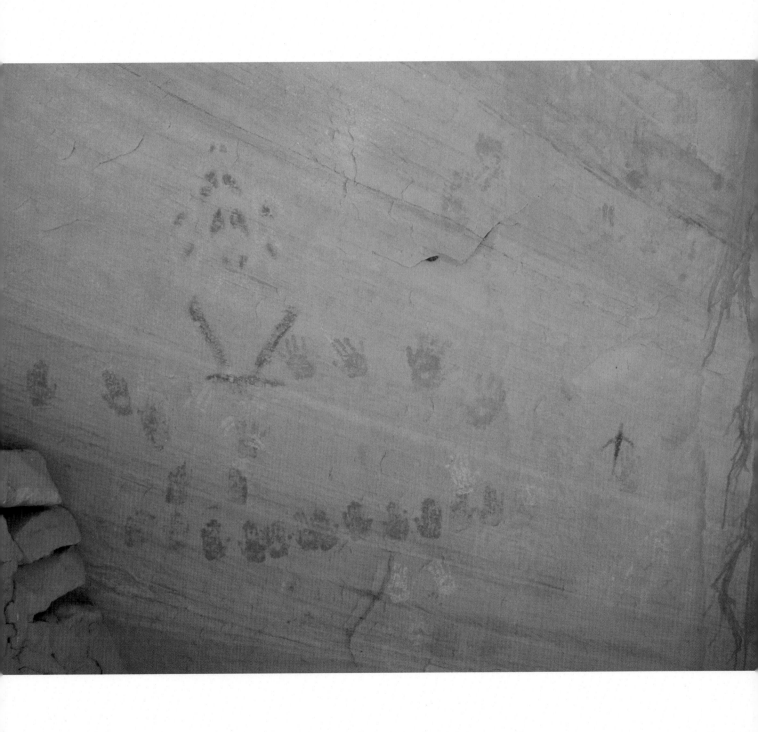

I have a name, damnit! I have a name! Lance Cpl. Jeff J. Ready. J for Uncle Jonathan, proud Marine before me. Family tradition. Shared values. Tribal totem. Semper damn Fi. I have a name, Sgt. Turk, Sgt. Lee. I have a name. Say my damn name. I can't hear you! Say it aloud, like you mean it. Say it aloud! Say it! Now you owe me. We owe each other everything, Danielle, remember that. Remember me, please.

Miss Malvern, Mrs. Malvern, what is a human when the human part is gone? Just clouds of hands on a wall in a canyon in a cave? Just rock tracings saying we had hands, not paws, and we were here before you, we were humans, and now we are all gone? Haven't we learned at all? That hatred kills and love enriches, the only universal truths? I'll just lay down here for a while, little one. Lie down on top of this sand ridge for a while, rest my eyes and head. Then maybe I'll get up and march on toward you. You know, Danielle, Daddy's always done his best for you and Mommy, our little tribe.

Shadows of birds circle overhead. Sorry I'm late, Mr. Skeens' Chevrolet. Laid down on the job. So tired, so tired, little face. Daddy's tired. The whole wide world has worn him down before it was his time. The ocean is a desert with its life *inside* and a sea of stars above.

Danielle, little one, Daddy's right leg hurts. So tired, tired of all the world's hurt. My whole body is covered up with a glowing hot blanket of tiny fallen stars. So tired. So tired. She has blue eyes, blue and deep and round and clear. There are falling stars all around you, little face, a circle of light, cool white smudges and streaks of tiny, falling stars. The cool stars are falling down around us, Danielle and Cheryl and me, a sparkling silver shower of cool desert rain.

After

Lance Cpl. Ready's family has charged that the commanders' failure to report Ready missing for almost 48 hours dramatically reduced his chances for survival in terrain where daytime temperatures averaged 120 degrees and humidity levels were less than 5 percent. The initial three-day manhunt did turn up Jeff Ready's helmet, flak jacket, backpack and a stone arrow he fashioned to point rescuers in the direction he had walked for help, but the Marine Corps suspended the hunt when dog teams lost Ready's trail and the many searchers found no further sign of Cpl. Ready.

In early November, over two months after Jeff J. Ready had been left behind, the Marine Corp searched again, finding two more crude directional arrows and a set of footprints about four miles from Ready's final resting place. The second search was likewise abandoned. A month later, the San Bernardino County Sheriff's Department conducted a practice search exercise, using the Ready case as a basis for the practice scenario. Covering a wider area than the previous searches, sheriff's deputies stumbled upon Jeff Ready's M-16 rifle, camouflage clothes, wallet and military identification card. Several dozen yards away they found a sun-bleached jawbone. Scattered across the sand and rocks were numerous other skeletal parts, all picked clean. In the days that followed the grisly discovery, Ready's company commander and also his platoon leader were relieved of their commands. In 1990, First Lt. Lafer, Sgt. Turk, Ready's squad leader, and Sgt. Lee, his platoon sergeant, faced courts-martial on charges of dereliction of duty. The charnel pile of Jeff J. Ready's remains was discovered just off the border of the huge Twenty-nine Palms desert base, 17 Mojave Desert miles from where Lance Cpl. Ready had been fatally left behind. He had stumbled bravely to within one mile of a major highway. Contacted at the Ready home in Cleveland, Jeff's father had these comments: "It was a combination of goof-ups…Local park rangers said Superman himself could not have walked off the base in those extreme conditions. My son damn near made it."

"It was an obvious breakdown in the personnel reporting procedure," a Marine Lt. Col. Spokesman reiterated.

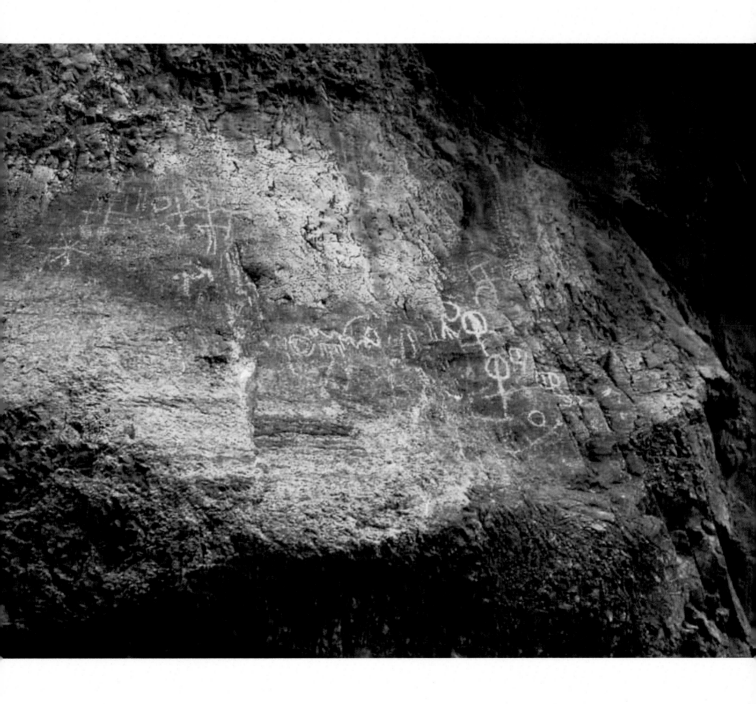

A *Los Angeles Times* editor wrote: "We printed Jeff J. Ready's true story because his situation touched us and, we hoped, would touch others. It's not that we must now give him a 'death with dignity.' That's not ours to give. It's just that Jeff Ready's plight seemed so much like our own: lost, forgotten or never known by the world at large and so often all alone, with only whatever we have within that makes us unique, that makes us human, to keep going, to keep from giving up. We know that Lance Cpl. Jeff J. Ready must have been a special human being, endowed with and touched by love.

In the end, all of us will be for the most part forgotten. Few of us, though, will have the courage to walk so far. Jeff, we salute you."

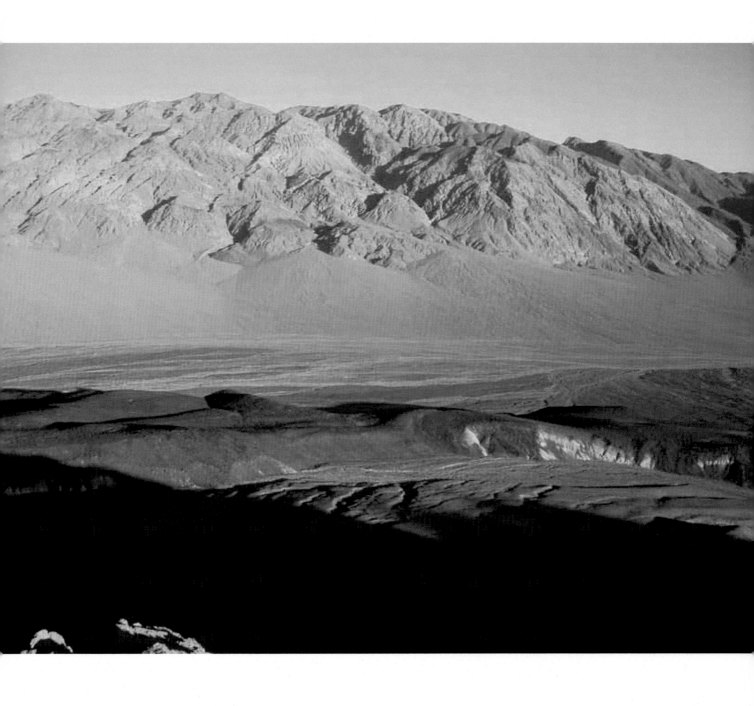

"Mango Salsa, This is life; life is this"

A man and a woman talked in a bar called "The Rusty Scupper," famous in Wildwood, N.J. for its homemade mango salsa and its two dollar boilermakers. "If you're a guy, it's happened to you, getting your pecker caught in a zipper track," the man said. It may have been when you were hurrying, maybe sometime in elementary school, when your little friend is pretty small and you've got a hall pass to go do your business, before those days when your little friend is so engorged wiThexcited blood that he pokes up behind your belt buckle, saying a surprise, unwilled hello to all the public world, before he seeks to poke your would-be mates, but, if you're a guy of any age, it's happened to you."

The man, recently divorced, was good looking, big and blonde with a pirate's rusty blonde moustache and goatee, had sparkling blue eyes, but he was pressing his luck for first-date chance encounter conversation. This woman, tall, lean and hazel-eyed, was equal to the task. She had no trouble mixing homemade mango salsa, blue corn chips, anatomy and physiology, whiskey and beer.

"Yes," she said, amid John Cougar's "Jack and Diane" jukebox music and other, louder, less intimate conversations. "Yes, maybe when you're old and your little friend is hanging down, limp, and you're dressing for pot roast dinner at the nursing home, hoping to impress the widow Douglas, maybe then, because your eyesight isn't so good anymore, maybe then you get caught."

He saw her smile wickedly. The jukebox sang, "Oh yea, life goes on, long after the thrill of living is gone." This felt pretty thrilling to him as juices flowed, and, he thought, as he drank his second beer, seemed thrilling to her, too, if that smile playing at the corners of her mouth and that stray lock of hair that she kept brushing back off her forehead coyly, blue-green-hazel eyes boring in right on his, were any indication.

"Oh yea, life goes on…" she sang. This Diane had powers of empathy, it seemed. Maybe she'd had brothers, most likely a husband, definitely a father. She knew.

"And it hurts like hell," she said between choruses of Melloncamp. "Exquisite agony while you try to figure whether to unzip down against pink-white flesh, or whether to zip up, which way would cause the least pinching damage, up or down, pick your poison."

"Yep," he heard himself say as she dipped a triangular blue chip in salsa, scooping it up gracefully, crunching the dipped chip without spilling orange. "It surely has happened to me. The zipper that binds…us, we guys anyway, all together."

She laughed out loud, the song ending. "This mango is great salsa," she said. Then she fi shed in her

purse for a little notepad, to give him her number he wondered, hoped really, and for a pen. She had been separated for six months.

Someone's cell phone rang nearby, an annoying Usher song ring tone. This Diane drank her new boilermaker, whiskey in the floating shot glass first, in two or three swallows, then her Rolling Rock second, in six or seven larger gulps. "Very good mango salsa, she said again." She smiled that smile, began to write on her little pad.

This Jack shot a glance at the group of much younger people, barely 21 it seemed, at their nearby table, at the young redhead who nearly shouted over the new music into her cell phone, "Whatsuup, girlfriend?" This Jack didn't hold back with his Diane.

"Never have so many had so little to say so often and for so long since the proliferation of cell phones." She looked up from her nearly secret writing, her sudden cursive hidden by her cupped left hand, right hand brushing that delightfully unruly chestnut shock of hair away.

"Amen," she laughed. "I want to get a tattoo just to be different like everybody else."

"No, you're right," this Jack said. There comes a time in every single eligible male and female's seductive dance when first one and maybe the other decides that they are invested, that they are in for the chance. The chance at romance. This Jack was in.

"I don't know why they call them 'Rest Rooms,'" he said, blue eyes right on hers, now downcast as she went back to her cursive. After two boilermakers, his thoughts had turned temporarily to bathrooms. "There's no rest in there, no taking a nap or lazily reading a novel. Going to the bathroom is more like work."

Diane looked up at him coquettishly, nodded, "You make sense." Then: "I'll be through with this in just a sec. Tell me a story?" she asked.

This Jack grew quite fond of looking at her face. He ordered another basket of chips with salsa, two more beers. He had to think up a story. Quickly. Then it hit him. The reason he was here. Not with ontological status. Just here at "The Rusty Scupper" with beautiful Diane while Keith Urban's latest played and she scribbled what he hoped would be a further invitation. It was the true story that changed everything. The year before, he'd lost his wedding band. So it went.

"At the risk of sounding like I'm whining and complaining on a first date, if that's what this is, at the risk of sounding like the cliché of how two beat-up separated lovers, if that's what we are," he said, "here's my story. Last winter, I lost my wedding band," he said. Mango salsa and two more beers arrived and were paid for with their co-mingled bills on the small round table, and they dove in.

"My wife and I were already on the outs, fighting unproductively like cats and meaner cats. Sometimes

we shouted over old wounds so loudly that I know the neighbors on both sides must have heard things they should not have heard. So anyway," he said, between crunchy bites of blue chips and tangy orange salsa and deeper draughts of Rolling Rock beer, "we were a sinking ship taking on water so cold it was almost ice.

The talking heads on the Weather Channel called for a big blizzard right over our heads, two or three feet of snow," Jack continued, looking suddenly a little worse for wear. "I had a lot of outside work to do, you know, to get ready for the storm. Normally, I'd take my ring off before working outside, but this time I remember seeing it on my left hand ring finger when I pulled on my gloves."

Diane knew he needed some cheering up. She knew how to listen to silences between words. Knew things. She finished writing, said, "Come on sport. Have some more salsa. Life's short."

Pirate Jack sailed on. "So, I dragged our old snow blower out of the storage shed," he said, flashing her his best world-weary smile. I dragged it out through our locked gate, took off my right glove to undo the lock, parked the machine in front of my garage to gas it up, then got out my tools to put in a new sparkplug, tune it up. I got the thing running sweetly, then got out my rock salt, spread it all over the driveway, each arching throw of salt of hundreds done with my bare right hand stinging against the cold."

Jack drank his beer, ate more chips and salsa. Diane put her hand on his left hand, cool and smooth. She handed him her scribbled notepad page.

"Not to interrupt," she said, "because I want to hear it all, but it's just that I think you need this."

He carried the ship of his thoughts, remembrances. He uncrumpled the paper she'd laid gently in his right hand. It was a little "Rusty Scupper" poem out of their new relationship. It was wonderfully, excitingly brave to him as he read:

"Of This I Am Almost Sure"

What-
Ever
Love brings
I will
Have
No
Regrets:

Only
Smiles,
Light.
Only
Mango
Salsa,
Beer.
Only
You.

Jack smiled broadly, a happier mustached pirate with only the rest of his story to finish, to tell out loud. "Thank you," he said.

"Not to worry," Diane replied. New music played loudly.

"So I made all these preparations for the storm. Laid out snow shovels, went in and out through my fence gate, back and forth, thinking of my family warm inside the house that was soon to be no longer mine," Jack said. "The last thing I decided to do was to gather up some fi re logs from my stack of wood out back. I don't remember if I took off any gloves for that, but I know the wind was already howling.

I came inside my house through the back door, with no one to help me open the door with my armload of logs, as usual, and I maneuvered my way to the fi replace doors, past my wife sitting on the sofa watching her beloved T.V. I got those doors open, swung the chain mesh apart, tossed the logs on the hearth rack for that night's fi re and arguing.

That's when I noticed it. When I took off my gloves, left and right, it was gone. My ring. Right in front of my wife. Gone."

Diane sipped her beer, looked right at me, strongly, chestnut hair framing the fi ne, interested features of her face. "What did you do?"

"I took the largest ration of shit any man could swallow and more," Jack said, regret tasting more tart in his mouth than the taste of whiskey, salsa, chips and beer. "That day, after she read me the riot act and after I searched the old fi replace ashes and all around inside, I mounted an outdoor campaign.

I retraced all my steps, the storage shed, the gas can, the snow blower tracks in the dirt, the gate and lock, the toolbox in the garage, the salt bucket, all over the extended driveway and then out back again at the rotting woodpile. I went back over it all again and again until I lost the light. Even then I went back out with a flashlight until the snow covered everything up. In the morning, when I awoke to

frosty the snow wife, there were 27 inches of snow on the ground."

"So sad," Diane said. Her hand still touched his, skin to skin.

"It came up every day in the beginning. I was a liar. I had thrown it away. Maybe I'd left my ring in a foreign bedroom on some bedside table. I was a liar. Maybe I'd left it in some hotel room, she'd yell, veins popping in her neck. Maybe I was having some cheap affair.

After a while, it was only once a week or so, always the ring. Sometimes a month or two would pass, but the specter of the lost ring never went away. A year went by."

Diane, the poet, asked, "And?"

"And we split up right after our kid graduated from high school. Went our long separate ways."

"Damn, that's sad," she said.

"Wait, it gets better," he said. "And worse.

After I moved my things out, got my own place, a bit of my own life, I went back to the house to do some things for my daughter and my future ex-wife." This was costing pirate Jack, as all things worthy do, but he sailed on almost blithely to the end. "On my survivor's guilt 'to do' list was cleaning out that damn fi replace. I shoveled out all the ash and cinders into a big bag. Hauled it outside by a big trash can. I took a perverse delight in taking off one of her new window screens to sift my ash with…"

Diane laughed, threw her head back and laughed out loud. Perhaps she saw it all coming.

"The ring was the end of us," Jack said. The music around them completely receded into the background now: transparent. "My losing it, her bitter reaction. It was just the end of us.

The end. And it was the very last dollop of ash that held the ring," he said. "I had shoveled it into the bag first, from the front of the fi replace where it had lain hidden for a year, so it came out last from the bottom of the bag. I saw it there, a blackened gold loop, dull and soot-covered against the window screening, buried in burned ash." "What did you do?" Diane asked, her hand still on mine.

Jack looked her back strongly. "I thought about dumping it back in the trash can, ending it all there once and for all and never saying a word. But I wasn't enough of a man to let it go. I wanted some small measure of revenge."

"What did you feel?"

"I didn't feel relief. I felt the old blood anger. Wanted to rub it in her face."

There seemed to be no music, no others in the "Rusty Scupper," only two at their round table.

"I told her I'd found it, that I'd never wear it again. I tried to rub some of the black off, and, when I couldn't, I threw it in a jar in my old house. And I walked away, leaving it all. Forever."

"And here you are," Diane said. "With me."

"With you."

Her fingers rubbed his hand. He felt her feet touch his under their seafaring table.

"Tomorrow is another day," she said invitingly. "There will be fresh mango salsa."

He felt the tipping-point tilt first one way. "Tomorrows have a way of turning into yesterdays," Jack said.

And then the other, better way.

"I want all my tomorrows to turn into todays spent with you," she said.

It was the nicest thing anyone had ever said to him in all his 49 years.

"What the hell is your name?" he asked, smiling sadly, boilermakers saving him from sailing away on a nostalgia sea of not-so-good old days.

"I'm Tim."

"I'm Kate Ann."

"Yes," he said inside and out. And her name was the second nicest thing anyone had ever said to him.

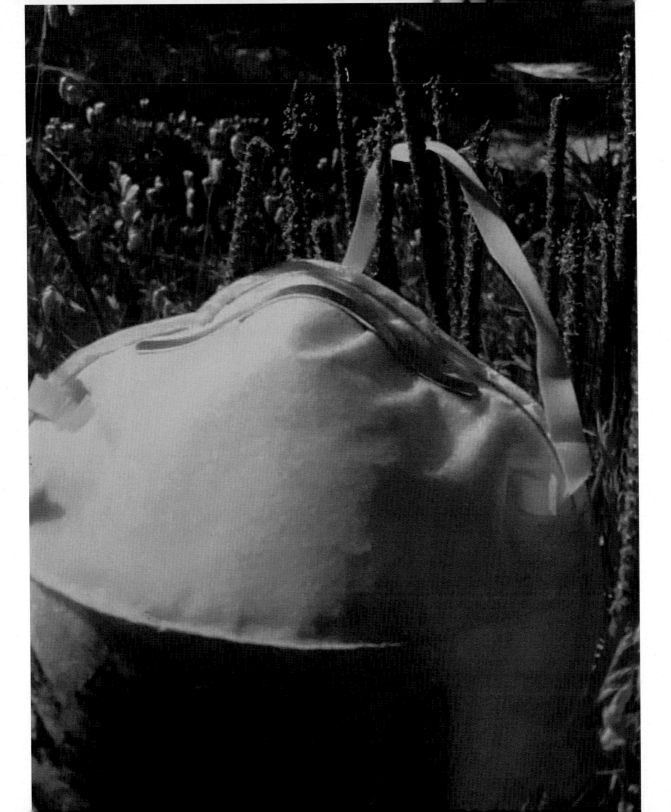

"Covid: Before We Knew"

It wasn't any fun at all. Things hadn't been fun for a while. We didn't know what it was at first, this Covind virus like Ray Bradbury's "There Will Come Soft Rains"with dystopian particles falling down from the sky and into our lungs. We were children, innocents, but it all changed when an old man with a combover appealed to our worst instincts and became President after reality became T.V. and T.V. became reality.

Devon had turned professional, you see, assisting deaths for a part-time paycheck, not because he didn't care anymore, but because he cared too much to let fate bring the sick ones to him. He went to them, and by early 2020 business had picked up a bit. He knew this firsthand, in the Zoom rooms of soon death and death, but he didn't know anything until later. None of us did, except the old man with a combover who didn't care, who appealed to our worst and who lied everyday on social media and on TV. Devon's reality was to become much worse. All of ours' was about to…

What we didn't know did hurt us, and it hurt us badly, down to the core, but it also taught us new ways to think… ***Covid, we would learn, Covid 19.***

Devon grabbed as many rolls of toilet paper as he could carry at 6:12 am on a Friday in his local "Acme." A man wearing a gas-mask barged by him, his arms burgeoning with four packs of toilet paper and pack of rolls of paper towels, rising to his be-masked face. Devon could hear the running man's very breathing, vooooot, hoooot, voooot, filtered in and out, for a second or two as the sound and the man receded down the over-lit fluorescent lighted aisle signed as "Paper Goods and Home Products" above the neutral-colored Lozier long aluminum shelving and under the harsh light.

Jesus, God, Devon thought, ***What an asshole.*** But his own breathing was labored when force-marching back to his overfull shopping cart, left sentinel by the empty shelf tabbed as cleaning products. A "Cinnamon Life" box lay beneath his cart, and Devon grunted as he bent to pick it up and throw it on top of the pyramid of groceries on the cart, now capped with his prize of toilet tissue rolls and among the Bib/Boston lettuce heads. Voot, whewww, hoot, voot, he heard his own labored breathing, felt the pulse beating in his neck, violent hammer on softer nails.

"During this unprecedented time," the loudspeakers above said flatly, "Acme and its employees put safety as our number one priority. Masks will be worn at all times by all customers and employees, and we will take steps to protect both our employees and our valued customers." ***I wonder how valued I am,***

Devon thought, pushing his cart briskly, following the newly taped arrows on the floor pointing "one direction" past the aisle's end-cap, toward the next aisle. Voot, whewww, hoot, vooot, the air moved in and out too rapidly for proper cadence.

"Safety is Acme's number one priority."

He knew that Kathy, his second wife and namesake of an old girlfriend, was sick and tired of taking care of him, nursing him through a severe depression, one that left him most often in bed with the covers pulled up high over his head, hiding, wasting his precious days, but she was here with him…Somewhere.

He forced marched back to the Acme aisle where he'd left her, forgetting the voot, hoot, hoot and whistle of his breath moving, remembering his proposal in the dead of winter in Vermont when their breath hung in clouds of spent life around them, feet in the deep snow, in a love that seemed only a memory now. *"I f…..ing Love you!," he croaked then, the snow swirling all around them, in Killington, "Let's get married!"* Somehow, she'd said yes, not knowing how much of a commitment that really was, to a man who had PTSD as only one of his foibles.

Kathy wasn't where he'd left her, wasn't what or where she was supposed to be. Instead, she was her own woman; instead, she was at the end of the produce aisle, watching him with a bittersweet mix of love and disgust. Voot, hoot, hoot he marched up past the deli counter with its six feet apart-take-a-number patrons shuffling back and forth on their non-descript feet, the gas-mask man next in line for a half-a-pound of bologna, Devon spying her with relief and dread, tramping up through produce, past more bananas, apples, cuties that didn't look too cute, past the iceburg lettuce and can't-elope as they used to jokingly call it in better times. *She didn't wait for me,* he realized late, *will she wait for me to get better?* He thought, fearfully. This *goddamn virus*, Chinese against their will, had made them worse, right at a tipping point when he needed to step up and get balanced. Start over, again. *Covid 19. Six feet apart, N-95 masks on, to avoid that very same six feet under…*

"What the hell took so long," Kathy barked as Devon at-first tossed the paper goods on top of her overburdened shopping cart, then realized he had some room left on the bottom compartment of his panic-shopped shopping cart, and slipped the case of toilet paper, "soft as rain" under his wobble-wheeled cart. "I've been waiting here forever," she snarled. "What the hell?"

So it went in their marriage; so it went in those early pandemic days, when we did not know what was coming at us like a runaway freight train, economy car stalled on the tracks occupants too drunk with enuii to burst out of the doors to safety.

"What do you want from me," he said flatly, under his labored breath. Then nothing, a vignette of

rushing shoppers stilled in groceries and under harsh fluorescent lights, stilled and slowed down by his slumbering mind.

"Squirrels are the original panic shoppers!," he tried, forcing the joke, the effort the words, the life. "They got here first. Raccoons already had their masks on too!"

"Funny," she said and seemed to mean it. He felt a stab of genuine affection surge through his adrenaline filled body. Everything seemed enhanced, on edge, tipping points all around them, around the country, around the human race, all of us with *PTSD.*'

"I'm faster than you," Kathy smiled.

If you want to go fast, Devon thought, suddenly inexplicably afraid, *go alone.*

They pushed their overburdened carts in a small row, Kathy leading so as to take up less width space as others milled in un-neat rows of walking, flowing only one way on each aisle of sparse groceries, red arrows reading "This way only" punctuating the Acme's yellow linoleum tile floor.

If you want to go far, go with your family and friends, Devon thought, cued up in their busy checkout aisle, plexiglass blocking the checker from the many mouths and faces and noses of the public. A lady with two carts pushed her many groceries onto the conveyor belt, seeming harried and at wit's end, she sandwiched between her two carts. A four pack of Scott toilet paper fell to the tile floor right in front of be-masked Kathy, his bride, who bent to pick it up.

"No," the harried woman barked. "I'll get it: it's not safe!"

"Forgot," Kathy said apologetically, rubbing her nose unconsciously, "We're still all getting used to this virus nonsense."

"No worries," the new intimate stranger said. She went about the newfound intense checkout process, the pimply-faced and scared clerk scanning the barcodes behind the plastic shield wall, the scans chirping with each item.

I strongly recommend that you don't travel through life alone, Devon thought.

The road can be too dangerous.

Then it was…

"That'll be $540.57," the clerk said flatly, though a mask labelled "Amce Ace."

They *are* heroic, Devon thought, "front line worker" was the new term. First rate in a time of pandemic, or what seemed a new dark age, ushered in by an old man with a comb-over who had betrayed the country's trust and dishonored the Office.

F…ing Putin, Devon mused. *The President in bed with F…ing Putin.* Who would have ever thought it. Devon mistakenly swiped his credit card, USAA, in the side slot of the reader machine.

"Chip" on the bottom slide, the clerk said, he seeming to be about 20 years-old.

"Probably a Bucks student," Devon thought. **Betrayed.**

He pushed his card in the slot at the bottom of the reader. "Do not remove," the LED readout read. He did not remove. **Tyrant.**

My second wife, Kathy, doesn't understand. She never knew Kathy Heller and m y old life as an amateur mourner: for that, I cannot blame her. Kathy is smart enough for sure; she runs an office at the College. But she has no time for Depression, cannot let in the rising numbers of Covid deaths. And they rise everyday… a 911 every bad day…

I Zoom by day with my college writing students. They laugh at my jokes, just like before the damn virus. They ask me earnest questions I can answer, about the use of MLA in their research essays. They ask me some questions I can't answer. Are we safe? When can we come back to school? When will I get my stimulus check so I can finally afford my books?

Instead I distract them sometimes. We practice pretend insults. I tell them a ancient Syrian insult: "May you someday own a palace with a 1,000 bedrooms, each resident sickened by boils," but it isn't funny. One of my students quotes Langston Hughes, "I, too, am an American." They are all Americans, my many Bucks Countians and distance learning students from around the country, the world, my Patels and Shahs, my Smiths, my Lubanovs, my Risques, all Americans, and we need to hang together here in the ether, the virus and its destruction of families all too real…

"Write in your journals," I tell them. "Take walks… Get away from your Pod of people by going outside when you need to. You don't want to fall victim to the astronauts-crammed-together-in-the Space-Station-crowding-syndrome, and you don't want to resent your fellow family astronauts as we sail into this black pandemic of space orbit we don't yet understand."

"*You are valued*," I conclude one writing class with, feeling my skin crawl with imaginary, biting ants. I mean it, but it is harder and harder to buck them up. Chameleons change their skin color to reflect not just camouflage but to reflect their inner emotions. My face feels chameleon red when I close these Zooms, trying mightily to impart strength, upbeat attitude.

They are so earnest, so real, and we write sentences together to parse for fun, to while away the hours, make the hours Zoom. A short, complex sentence: "As soon as we installed solar panels, it rained for

nine days." Another complex one: "She ran, unafraid, full-sail, into the high seas of a 'Filene's Basement' wedding dress/bra and panties sale." Some giggle behind muted microphones on laptop computers, all wirelessly wired together by Verizon and Comcast and Science. We need to listen to Science and the real numbers, if we are to survive… A sardonic and risky student has a sentence idea, and I am afraid to let it go but figure what the hell. I have achieved tunure, but what does it mean in a world that is falling apart at the lungs, with blood clots and so many graves dug that trenches have come back for the bodies, like the World Wars, more like "War of the Worlds?"

He writes on his Share Screen white board: "He acted as if his penis were an instrument in the Boston Pops' percussion and slide Trombone sections!" I imagine and see snickers behind the many muted microphones…

But their questions hang in the recorded Cloud like whispy, thin cirrus actual clouds while I struggle to answer their concerns honestly, without lies or without too much Polyanna optimism that I am not capable of…

The pandemic has been good to me. I should explain. All the uncertainty and doom and gloom for our great country, for the whole human race, all of it distracts me from my own self-worry, my own anxiety. The plague has given me purpose.

I Zoom by night and weekends or whenever they need me, the sick, the dying. I am a part-time *facilitator* in this time of darkness when families can't be with their loved ones in their time of need. I *facilitate* with the medical professionals so that family and I are together in the Zoom and real rooms of the dying.

Last April, there were 273,899 confirmed cases of the plague and 7, 492 dead, and we were just getting started in the United States. This April, we had 31,938,305 confirmed cases of Covid 19 and 572,512 deaths and rising, deep in a fourth wave of new variant infections, despite a quarter of the country already being vaccinated.

One of my students told me, sheepishly in a private Zoom, "I almost wish that everyone who thinks that the virus is a hoax would come down with it and die." He lost a parent to the virus. *So what am I to say to him? Who am I?*

"We have to be better than that," I said, "We have to do better, to rise above, like Ghandi." Secretly, I hated that I'd read that there was dirt on Gahndi, that he was no Saint…

The numbers don't lie. Those who don't believe them are full of shit. One can't selectively believe in numbers on bank ledgers, saving accounts, interest rates, the calculus of love, the Prime Rate, rising cancer rates, without also believing in the objective numbers of viral public health. To believe in some numbers without the others, to believe in a hoax theory, is folly of a most dangerous kind. *Ignorance can kill, does kill.*

Knowledge is healing when it is shared. "*She that plants trees loves others besides herself.*" *The plague numbers do not lie, so it is time to plant trees…*

I sit at my laptop computer, alone, red-faced, ants crawling on me, at the end of each teaching Zoom, wondering "have I taught them anything?" I have no numbers on that.

The dying Zooms and the dreams that come from them are different but certainly no less raw.

Devon's wife is beautiful. Her freckles dance on her cheeks in the summer sun; her blue eyes sparkling in that same sun, her light brown hair shining as she laughs with the tiniest of laugh lines around her mouth… His second bride and Devon have two kids, a ten-year old boy who shoots baskets way above his head, above his age, practicing for hours before the pandemic, during the pandemic with a mask on, behind the garage filled with bicycles that sit unused. Devon hears the basketball bang and bounce of his Michael shooting tall baskets for hours, missing, making, still trying. Devon and Kathy have a daughter, Cathy with a "C," who is four and paints/draws/blows bubbles and is smarter than even her brother Mike. She has a pet chameleon named Ralph that changes his skin color dependent on its emotions, sometimes light green, sometimes deep forest green, sometimes almost magenta. Lately Ralph has been reddish when his terrarium basks in the glow of the news on T.V. in the living room. He listens to Dr. Fauci but doesn't understand the words Fauci says, just the feeling of controlled dread. Cathy's hair is blonde with hints of her Mother's light auburn: she is her Mother's daughter, an artist and Princess of play and creative invention who likes to hug. It is only safe with Daddy and Mommy and sometimes even Mike, but Cathy with a "C" likes to hug as often as she can. The basketball bounces for hours.

All I want them to know is that even though Death wins everytime," Devon thought, "*is that they are loved so much, in this world for now and all time and beyond. If life is unfair, we must counter that by being always kind.* Kathy and Devon teach their children to be kind, above all. It is the only lesson that matters.

Sometimes Devon wakes up, and, in the haze of half consciousness, the Virus is miraculously gone, just as before the Plague. But then he hears the T.V. and numbers, and the mirage vanishes and the Virus is back among all of humanity, threatening his kids, a cruel April Fool's trick. Sometimes the dying and near-dying Zooms nearly break him.

One day, when Devon awoke, he remembered a dream Zoom to anothers' life, all of our lives.

"Is it OK to record this Facetime,?" a devoted wife asked in the Zoom dream. I want to play this back for my husband when he is better…

"Yes, I see. It's fine," the Doctor in the dream said, white coated, covered in PPE, including a face shield that made his brown eyes look bigger, like saucers of concern. "I get it, I understand."

"Thank you… there; we're recording…Will Bill be O.K.?"

Those eyes got bigger, rounder, softer. "As you know, I'm one of several Doctors caring for Bill. We've run lots of tests, and everything indicates that he's had a stroke. We given him clot busting drugs…"

"A **stroke?!** But he's only 57!"

"Clot busting drugs… We call them Drano. We've run three C.T. scans, and it's very clear…"

"He was only 57 last month, in March! How can Bill have had a stoke? I don't see how that is even possible," Bill's wife said in the Zoom dream. "How?"

The Doctor in the dream seemed suddenly weary and let his shoulders fall into a slump. "I'm sorry. It's possible. It happens, it happened.

"Before the Pandemic, we've seen cases of acute ischemic strokes in middle-aged people. Since the Virus, it has ramped up considerably."

"Wait. You are losing me… I…"

"We hope he will recover," the Doctor said in the dream/nightmare. "It's at least possible…

"But we need to know more. Do more testing. We need more history before we can move forward."

"History?"

"Not only his record," the Doctor said, "but his recent travels, for contact tracing."

"Contacts?," Bill's wife said with some new foreboding.

"Yes."

"Do you know, say, whom your husband came into contact with in the last 14 days?"

The Doctor put his hands on his I-pad in the Zoom dream.

"We visited my Mom last Monday, the 25th I think it was. "She's in Croydon. We live in Fairless Hills. She's 90 and lives alone.

"I think I can see where this is headed," Bill's wife said in the Dream. And I'll cooperate, for sure, but tell me the truth. What's going to happen to my husband?"

The Doctor looked pained through his plexi-mask. "We do have some of Bill's records. Family history of high-blood pressure, heart disease and cancer don't help…

"And it might be a bit late in the game for more blood thinners, plasma activators. It was a fairly massive stroke. We are going to have to wait and see.

"Tell me more about where he's been in the past two weeks, for the record," the Dream Zoom Doctor said.

Bill's wife twisted her wedding band around in circles on her left hand. "How is Bill right now?," his wife demanded.

"He's… un, unresponsive," the Doctor said flatly. "As I mentioned, it was a massive stroke."

"You said 'fairly' massive," the wife argued. "'fairly.'"

"I shouldn't have said that damn adverb. It was massive."

"Massive! In his brain? What side?"

"The left…"

"So speech and language," she interrupted. "Writing and Reading. Goddamn it, he's a writer!"

"Yes, a large instantaneous stroke: he probably had no inkling of it ahead of time."

"Is he in pain?"

"We don't know, but he is **stable.**"

"Stable? For how long?"

"We don't know," the Zoom Doctor said, "but what counts is that he is stable now."

"But he had no other symptoms other than shortness of breath and a cold!"

"That's the Goddamn Covid," the Doctor said, adopting Bill's wife's language through some sudden empathy.

"We are finding that previously a-symptomatic middle-aged patients are having Covid-related strokes. It is very frustrating, and we need to learn more."

"**Frustrating**?!

"Frustrating. We're tired, and it's hard to keep up. I'm sorry.

I really am," the Doctor said. He was.

"What's his prognosis?" Bill's wife asked, adopting the Doctor's language through a little empathy of her own.

"Well, as I said, he's stable now, much better than when he came in. He was apparently still talking when he came into the E.R. He told his nurses, 'Help me, I can't breathe. I'm afraid I am **through.**'"

"He said the same to me," Bill's wife said.

"Is he going to live?"

"We are hopeful… Five more minutes before he came in and…"

"Well, the point is, he is at least alive."

"But will he be O.K.?"

"We'll have to wait and see. That's all we can do now. The rest is up to him.

"We'll have to wait and see."

Upon awakening, one Zoom-inspired Dream he didn't have to have as a dream unfolded in **reality.** It happened to Devon, himself.

My first daylight thought: Quick Lube. It's been a year since we changed the oil on the Minivan, despite not driving much at all. It's due on time, if not on miles.

It's time to see my own Mother, out there in northern CA, alone save for her Brittany Spaniel. Every 5,000 miles, she's due for an oil change, and I want to drive her 3,000 miles across country to spend two weeks checking in on Mom, but are the Lube places even open? Are they essential, necessary, like the very oxygen we breathe. "I can't breathe," Mr. George Floyd cried out, "I can't breathe!"

None of us can these days. Who and what is essential? Is it the Spanish-speaking maid at the Motel 6 in Kansas I nod to on my way back to the Minivan road on my way to Shasta County, CA? Is it my own beating heart, lungs filling with clean Midwest air? Is it the illegal immigrant who is printing masks and face-shields with a 3-d printer?

Who among us is essential? Whom can't we live without? Aren't the nurses we knew who got laid off because they worked on the wrong floor of St. Mary Hospital still essential? What folly to label a human's work as essential or not, when we all play a vital role in the whole picture. Isn't my Zoom teaching just as important as my Zoom death-assisting? Isn't it all part of the whole?

Ishi's dying words were, "I am going ahead. You stay here." Aren't we all here together, those who have not yet gone ahead? We are all buried or burned and buried the same ways. It waits for us all.

How is it one can be non-essential, when he or she or it is loved by others. That is the key, to love

and be loved. What folly to be not necessary, to be not essential to someone, something. What folly. To be Caronado by rioters or riot police... To be the one who stirred the riot without even trying, without willing it... All I can do is drive, stopping to teach these vague lessons to writing students with my "jetpack" when I can drive no further, when a $99 dollar a night Motel 6 is all I seek, save solace and peace. I see my wife all the time in travel, fever dreams, but she recedes like the miles of asphalt behind me as I draw closer toward my ancestral home, Redding, CA, where summer is King and winter used to be rainy Queen until the droughts came and the fires and my Dad died in the smoke and ash of global warming destruction, climate change. I wonder how long this old oil will hold up, how long the crankshaft bearings can make do with year old oil and the crossing of the plains to the Wasatch, where the Donner Party began to break down.

I do dying Zooms from the road too, teach the others punctuation and to be sparing with bold and italic, to always avoid hate, and I take my readings with the pulse oximeter I got lucky to get from Amazon before they all sold out. Leaving the motel one morning, packing my duffle bag of road clothes, alone, I was 85%, but I feel fine, am fine, am essential to myself if no others.

I knock on the door of my Mother's house, at last, delivered like a package, with the delivery-person, essential, ringing the bell to alert of precious cargo. There is Dad's old rosemary bushes along the driveway, but why can't I smell them? I am standing at the side door with dufflebag in hand, arrival announced vaguely by a call the night before, if not all the essential information. My hand knocks, my heart knocks, the minivan's engine might knock on the way back to Pennsylvania, God only knows, unless I can find an oil change place in Redding that's open, essentially, but I get no answers. I get no answer to the knocking on the door, and I ring the bell chime bell. Mom is half-deaf, but her hearing aides are good ones, and she should be here by now, even with her walker...

Then the whole Redding sky spins a bit, cumulous clouds punctuating a brilliant blue, and I feel heat rising even though it's only May and the semester is over save for final grades. The sky so blue you could reach up and scratch it spins. Last. When things fall apart. Dances. The middle will become the end. And where is the woman I love with all my heart, the one who taught me all of it? Why doesn't she answer before it is too late? The sky spins. Flags fly at half-mast all over America. "Illegals," "Aliens," "Undocumented." are dismissed and re-discovered and relabeled as essential, and the sky spins up a cloud-rush of blue and white.

I am home. I love you. All of you, even if some of you are ghosts. All is blue and white. Essential.

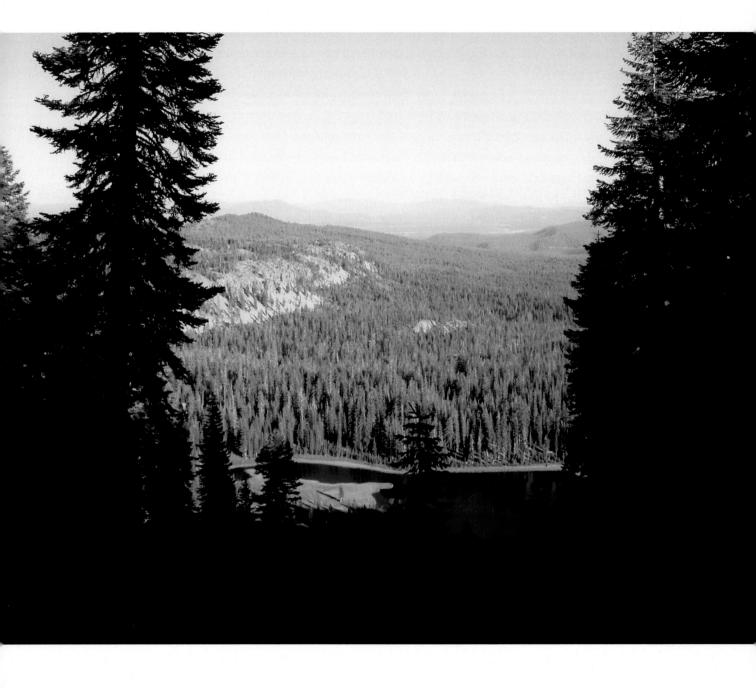

In the Land of Buttermilk and the Drakesbad Moon

Part One

Once upon a Drakesbad, CA Lassen Volcanic National Park time, many years ago, on one of the Freeman's first glorious visits to the Drakesbad oasis of high clean-air altitude tranquility, James H. and James Andrew, his son, set about chasing fish stories.

And fish sticks. And fish fillets. And legends, told by legendary Harry Daniel, son of even more legendary Warren Daniel, legends of native rainbow trout and long-ago planted browns and even more imported brookies, high up and inaccessible in the alpine streams.

Apparently, the story went, there were scads of fish from minnows all the way up to those self-same legendary 18 inch trout fining in the black and white volcanic fastness of rock pools, shaded back eddies, leaf spotted and cold fast-running under-boulder backwashes, generally hiding happy from humans who knew not of their existence.

And so it was, on that second or third Freeman family reunion high in the lowest Cascades and the top most Sierras, that the Freeman men, replete with fly rods, creels (for the fish of course), vests and sensible boots and hats and sunscreen, set off up country right before dawn, eating their full-dark breakfast of two children's cereal boxes and Ed and Billie provided skim milk on the raccoon-invaded porch outside slumbering Robin and Marshall and Andrew and Tyler (Alex was not born yet) and Leonice and Cindy (who was not truly slumbering because she'd yet to arrive) and Kellie's and Leslie and Ed and James' duplex cabin with such painstaking quietude that it was painfully obvious under the last of the star studded pin-pricked bowl of eternity above their heads called the Milky Way and its neighbors in time. And the raccoon enjoyed James H.'s soon-to-be heaped-on-cereal bran immensely. The stars, no doubt, enjoyed fading a little and then giving way to dawn and the two fisherman set off, unburdened of all cares, on the road into Drakesbad, itself nestled between two cat tailed and skunkcabbaged meadows where deer and a blonde fur-tipped bear named Buttermilk played below the mountains and the moon.

That's amore. That's the price of having fun. That is the best of times without the worst of times. And so they walked in the first light of dawn and another new beginning of time.

And walked. And turned up Flat-Iron ridge, with its steep switchbacks of pine scented, thin air that tested lungs yet filled them with hope and renewal. At the top of Flat-Iron, the whole wide world of promise, or at least a big slice of Lassen Volcanic Park, the nation's least visited the brochures say, spread

out like a green colored story board before them, with its volcanic buttes and pyroclastic devastation punctuating dense green pine forest, conical pyroclastic dog turds on a green and black carpet that would never be erased except by God. And mountains, mountains spread everywhere, just as you would dream them there.

To the north, white topped Mt. Shasta hulked and called them forward into the further fastness of personally true myth time. Behind them, Mt. Lassen, the park's centerpiece and the reason for mountain double reflections in the many lakes and the post-card night-time backdrop, if you were lucky, for the August Perseids' meteor shower, where sometimes, just sometimes, one could see shooting stars cross vectors in the dark space above, like two lives coming together, as one floated in a midnight, 100 degree volcanic-water heated pool cooled with chlorinated and tempered by ice-cold stream water in one's buoyant chaise lounge held softly further afloat by one's noodles. Noodles floating our noodles just high enough to apprehend one billionth of all creation that was far more than enough…

They walked on, first up and over Flat Iron ridge and into the fastness of the three dimensional painting they now lived in for one glorious week, becoming so completely the breathing (hard) canvas that the world behind with all its other paintings simply ceased to exist. And they walked together.

The legendary King's creek emerged ghostlike from the greens and browns and blacks first, but it had hidden itself well with many fallen logs and many boulders crossed cooperatively. James H. had to lower himself first down steep granite walls with precious few foot-holds, taking the scary lead, to the ice cold rivulet and its legendary trout lurking in the early morning shadows. He already worked the virgin pools, fly line casting in curls and then straightening out, water droplets glinting in the sun before his hand-tied fly with its grey hackle would kiss the rock pool. By the time James Andrew made his way down the steep bank, boots sliding almost sideways like a telephone lineman's across the sheer rock, James H. had caught two or three glinting rainbow minnows, working his magic, and then releasing them with hand wetted care to get them bigger.

James Andrew worked the lower pools, so they were separate but together, almost always with eye shot of each other and glad of it, as they lived so far apart, he in the east, in Pennsylvania, and James H. quite near this God's country on the familial little (good) acre. The day grew and grew.

Morning became an afternoon of sun-dappled birdsong and breeze through pines and Douglas firs and conferences with rocks as tables to compare the notes of the day. Two alpine streams yielded themselves up notso willingly to the Freeman men, yet fish were few and far between. How many have you caught and released was the topic of one memo; another said the legendary ones were just too wise. A codicil held that, anyway, had they caught any lunker browns or brooks the eight miles of rough

hike they'd come in would likely spoil them before any hypothetical legendary, triumphant return to base camp. And then that particular meeting was adjourned to shared and embraced silence. Absolute silence, save for the natural world's breeze song and sunlight and shadows, in this place untouched by the hand of man, the way it was, ironically, for tens of thousands of years of change.

And, after it was time for the vegetarian sandwich lunches, with two cranberry juices and a water each, and each in a brown paper bag decorated with caricature art by Ed and Billie's artistic Scandinavian or Chesterian (nearest American town) staff, well, after that breaking of bread between the father and the son, well, after that, there was no notion of time, yet there were timeless memories made.

MR. CLEAN

Michael Forbes had argued with his wife so frequently and for so long in their nineteen-year marriage that he no longer listened to her, and she no longer listened to him. For the most part, their union had deteriorated into what was, seemingly, two armored cars engaged in a delightfully neurotic game of bumper cars. He and his wife came out from behind the armor only rarely and only when some crisis involving their two teenage sons, Mike Jr. and Ricky, required it. The armored personnel cars came together even more rarely for sex: sex that was physically driven but metal-skinned and never truly intimate, so rarely that even the military's oil, filter and lube intervals were more frequent than their bumper car coupling and uncoupling.

Mrs. Forbes had even begun to consider an affair. It amazed her that she hadn't had one or two before. It wasn't as if men found her unattractive. Her brunette hair shone like a teenager's, and she still had the skin and chest of a much younger woman. Her hips and legs had widened considerably since she and her beloved John had said "I do" without having a clue, so long ago, what it was they'd be doing.

After all, there was the assistant manager Ray at the Acme. He always listened to her small talk in the aisles on her weekly grocery trips, always on Wednesdays, and several times she'd seen him looking at places he shouldn't be letting his eyes linger on too long. All the while, he masked his wanderlust with expressions that went far beyond hi-how-are-you concern. She felt sometimes with Acme Ray that he was reading her like a glaring cover of Star Magazine. Liz, a lesbian, being blackmailed. Dolly Parton's boobs not her own. Michael Forbes killed by hit and run space aliens…

And there was Raleigh Smith, divorced school teacher, not bad looking but increasingly desperate and attentive to her substantial emotional needs. Mrs. Forbes knew she could pluck him like an overripe tomato off a sagging vine.

Yes, Mrs. Michael Forbes had taken to active fantasizing and liking what she imagined far more than the routine skirmishing of her life.

Behaving almost like a female Walter Mitty, she adopted a new stridency with her husband, a confidence coming from the knowledge that she felt she had other options.

Michael Forbes, on the other hand, father, husband, sheet metal worker, found himself becoming more and more timid with his wife. It was as if his armor had been weakened or pierced, and he didn't have a clue why. Lately she says jump, and he just asks how high.

So it was that when his wife told him that their carpets had to be cleaned before the month was out,

told him with the new commanding timbre in her voice that five years of kids and dogs and boring family parties where somebody always spilled something had nearly wrecked their wall-to-wall rugs, told him that it was either professional cleaning, or all new carpet, or divorce, Michael Forbes listened. Within a few days, he began scanning the left over Sunday paper for coupons, settled on a half-price sale Sears was running, made up his newly influenced mind. Something was working at him, making him feel strangely insecure just when he'd thought he'd become a god to his wife and to the world, but John couldn't put his finger on just what it was or why. The very next day, after work, he called Sears and made the appointment. Within a week, he'd forgotten the whole thing.

She was at work when he got the call. The boys were finally the hell out of his hair, having belatedly and under much duress finally obtained their first part-time jobs about two or three years after all their peers. Michael was enjoying his peace and quiet, reading the sports section and drinking his coffee, watching a Phil Donahue show about gay head waiters, when his phone rang.

"It's Mr. Clean," the booming voice said. "We're only a few miles away. All your breakables cleared away? Chairs out from under tables? We're gonna be their real soon. Gonna get those spots."

As if struck by lightning, Michael Forbes remembered. "And on my one goddamn day off," he mutterer, holding up his receiver, listening to the dial tone of his phone, cut off . "This place is a disaster." He hung up the phone.

Michael Forbes abandoned his baseball scores, dumped his bitter coffee in the kitchen sink, then buttoned up the front of his shirt, leaving the shirttail out over his khaki shorts. He was barefoot.

He began scurrying around the first floor of his Philadelphia row house, hiding away the flotsam and jetsam of his family life as best he could on such short notice. Michael picked up the scattered newspaper, clicked off his big Panasonic TV. He put away his cereal bowl, threw two pairs of his son's smelly sneakers downstairs to the kids' converted rec. room. One of the size thirteen shoes hit the paneled wall at the bottom of the steep pitched stairwell with a satisfying thud.

Michael Forbes hurried to drag the individual chairs from his dining room table into his crowded kitchen. Sweat beads formed on his brow as he dragged a loaded antique bookshelf there too.

He thought of the bottles of Resolve carpet cleaner he'd had his wife get at the Acme the week before. Shit, he remembered, I was supposed to pre-treat the worst of the grimy spots. Can't remember shit club, he thought as he worked, card-carrying charter member. He thought of his wife his wife, of her newfound assertive verve. Jump, jump, he thought. Just tell me how high.

He heard a truck pull up to his driveway, then scrape bottom as it labored up the steep pitch to his front of the house parking spot. Got to fi x that, Michael Forbes thought. He heard his doorbell fail to

ring, then heard someone knock loudly on his battered front screen door. Got to fi x that too, he lamented.

"Mr. Clean and his assistant here," the voice boomed. "Here to wage war on ground-in dirt." Michael Forbes opened his heavy wooden door, then propped open his fl imsy aluminum one. Mr. Clean stood imposingly in front of him, and, behind, almost completely obscured by Mr. Clean's broad beam, a sheepish black teenager with an M. C. Hammer haircut lurked.

"Come on in," Michael Forbes said. He liked belaboring the obvious, but, before the words were out of his mouth, Mr. Clean swept impressively and barely past Michael, his teenage assistant trailing after.

"Got to phone in," Mr. Clean thundered. "Got a phone?"

The black man was a mountain. He stood about six-foot-three, but more impressive was his amazing width. He seemed to be about three feet wide at the shoulders and muscular all over except perhaps for a little well carried sloppiness around the gut. Mr. Clean had to go close to three hundred pounds, Michael estimated. Maybe more. Michael Forbes remembered reading a quote from John Muir sometime in high school, sometime in another life. "Give me men to match my mountains." John Muir had sent him Mr. Clean to attack his spots. "Phone's in the kitchen," Michael said. "Help yourself," he added. Then: "Watch out for the piles of stuff ." The sheepish teenager stayed in the unkempt living room, his arms dangling limp at his sides, as if he were conserving psychic energy, saving strength for some long task. Michael heard Mr. Clean dialing, caught himself counting the clicks to see whether the call was long-distance, and then listened in while the assistant stared vacantly.

"Mr. Clean at job seven, zip code 19114. Poor preparation. This might take a while. Bye, bye."

Michael almost smiled at the incongruity of a three-hundred pound black man with a menacing clean shaven head saying bye-bye.

"Got any paper?" Mr. Clean asked. "Left mine in the truck. We got some estimating to do." "Estimating?" Michael Forbes wondered aloud.

"Show me the upstairs?" Mr. Clean wanted to know.

Michael led the triumvirate upstairs, embarrassed at the reality of two total strangers leering at his private, messy upstairs rooms.

"What're all these stains?" the assistant asked helpfully as they marched up the stairs. It was the first time he'd spoken, and Michael was surprised that the boy sounded literate, mannered even. He'd half expected rap to come out of his mouth.

"Damn kids. I've got two kids."

Mr. Clean shook his head as he looked in Ricky's second floor bedroom. "Hmm." He scribbled something down furiously. "Hmm. You need bathrooms and hallways done too." "You had a dog in

here?" M.C. Hammer wanted to know.

"Yeah, Lady dog. She's out back."

Mr. Clean's huge and earnest face was broken by a smile. "Good thing, hey Chuck?" he asked the kid. Then he said to Michael, explaining: "Chuck and me don't always get the red carpet treatment from dogs." As if on cue, M.C. "Chuck" Hammer knew to laugh.

Michael Forbes, suffering the ignominy of publicly surveying the strewn laundry and private things of his master bedroom, felt Mr. Clean's huge and pressing hand on his back.

"Come on downstairs. We got some things to talk about. Some estimating to do."

"Estimating?" Michael wondered aloud again, this time a little more desperately. The assistant just shrugged.

Down in his dining room, Michael Forbes watched Mr. Clean spread out his borrowed paper, begin to work with his pocket calculator. There were tiny, glistening beads of clear sweat beginning to form on his bowling ball of a head. The big man mumbled out loud as he worked.

"Let's see, you got that half-off coupon the dispatcher told me about, you got seven rooms, two halls and two stairs. Some serious spills. Dog dander…"

"Excuse me," Michael Forbes, the master of the house, interrupted. "The lady on the phone said the whole place would be $159. Isn't that true? I'm only doing this to shut up my wife," he thought to add.

The big man looked up from his figures to turn his deep brown eyes earnestly on Michael.

"Mister, we got some talking to do." The kid shrugged again, turning his eyes away from the two men.

Mr. Clean was good at what he did. He took to his spiel like an English Composition student in search of an "A."

"Michael Forbes," he said, "you are a family man. We could do your house for $159, for sure. But what would you have? A few less stains and less crud, sure, but we'd have to be back here inside of a year." His head shone. His eyes were still on Michael, searching his face for reaction. "See, Mr. Forbes, you got some problems here, sure as I'm a stone black man. I wouldn't lie to you. You got dog damage, and teenagers spilling beer when you're away on vacation, beer and God knows what else. Maybe some of your own relatives done come over on weekends and dropped a beer or a soda or two themselves. You got some righteous stains right here under us. Look like they could be Chinese food. Maybe Mexican. See, Mr. Forbes, we got some talkin' to do."

"How long you had this carpet?" Mr. Clean's assistant asked, rising suddenly out of the background to the occasion. He's Polonius to Hamlet, Michael Forbes suddenly thought, then wondered, who said high school English doesn't pay off?

"About two and a half years."

"Whew!" The big man whistled. "Only two years. It look more like ten."

"Here's what we do, Mr. Forbes. We pre-spray the hell out of your spots, then we power clean everything down deep, like we normally do. But the kicker is we got to lay down lots of Teflon, Mr. Forbes. Else we be back here way too soon.

"Don't screw yourself, Mr. Forbes. You a family man. Got kids. Relatives. We don't put down lots of Teflon spray and you gonna be right back where we's starting in no time at all. You know you got somebody here who smokes? Hard to get out that smell."

Michael thought of Mike Jr., who'd been lying to him and his wife about his smoking for years, all the while smoking in the house with his loser friends whenever he could sneak the chance. All in all, the kid had turned out to be a major disappointment. Michael blamed his wife, always too protective, smothering really, far too quick to forgive. Michael Jr.'s cigarettes were only the tip of a Titanic-sinking iceberg that had melted all over his carpets, staining his life.

"And deodorizer," M.C. Hammer chimed in, jolting Michael Forbes out of his carpet-based reverie.

Mr. Clean took the ball on a handoff and ran like a rampaging lineman turned halfback for one glorious touchdown run.

"Yessiree, Mr. Forbes, Chuck's right, we really should deodorize. Especially with cigarettes and a damn dog. I know folks love them, but they play hell on us. We wouldn't lie to you.

"Did I tell you I'm an ordained minister, Mr. Forbes? So I wouldn't bullshit you. That's right, tell him, Chuck. I got me a little church in north Philly. Preach there most every Sunday afternoon." Michael grew weary of the game. He felt the pulse beating in his neck.

"How much are we talking now?" he asked directly.

The big minister turned his earnest face downward at the dining room table, furiously resumed his calculating and scribbling.

"Seven primary areas. Four additional. Half off the primary areas. Not including the pre-spray everywhere. Not including the Teflon. Not including deodorize. Let's see, half-off coupon on the primaries. Damn," he said, and started again.

He ran the ball right over Michael, looked up at him with a reminder, but was really looking down, one cleated foot pressed to Michael Forbes's heaving chest.

"I'm a minister, see, I wouldn't bullshit you. Did my training through University of the Arts here in Philly. Did the University Without Walls Theology Program right from my own home. Correspondence. Took two years," Mr. Clean's bass voice boomed.

100

Vanquished, his back on the thick, staining grass of the football field of all the many defeats of his life, Michael Forbes thought about whether Mr. Clean's carpets looked like his, for better or for worse. He thought about his wife. About how good it had been so long ago. About how they'd been slipping away from each other for years. For years now, he'd been half expecting Jimmy Stewart to show up at their door and give them the fatherly advice that they should stop hurting each other and work together like a team, like Chuck M.C. Hammer and Mr. Clean.

But Jimmy Stewart had never shown up, and they'd gone on tearing each other apart. The old habits never died.

It was as if Mr. Clean could read his mind.

"I preach about brotherhood and understanding.

Racial tolerance. So you know I wouldn't bullshit you.

"Mr. Forbes, don't screw yourself," Mr. Clean repeated. "Do the right thing," Minister Clean concluded effectively. He went back to his calculations.

There was what seemed to be a long pause.

"How much?" Michael Forbes repeated.

Minister Clean's eyes were again upon him, a mythical forearm helping him run the ball.

"I'm gonna tell you something I've never told no customer, Mr. Forbes. Something that goes no farther than you and me and Chuck.

"See, I own me a small block of apartments on Cottman Ave., ain't that right, Chuck?" The kid, growing perceptively bored, agreed.

"Anyway," the big voice rolled on, "some of the tenants are bonafide damn slobs. What some would call black and white trash. So every couple of months me and Chuck here borrow the Sears truck and equipment after hours or on a weekend. Make my tenants let us in. And we clean the hell out of my carpets. Our mixes do a helluva job. Ain't I right, Chuck?"

Again the youngster agreed, his arms hanging limp by his sides, waiting for something important to do.

Minister Clean summed up. "This don't go further than this room, okay? I only tell you to shows I know how to do a helluva job like I does on my own rugs. I own property. I ain't some big, dumb Black with a room temperature I.Q."

The word and the story surprised Michael, but he wouldn't allow himself to be run over so easily.

"How much?"

"Mr. Forbes, me and Chuck can clean the hell out of your whole family's house for $390.60. Protect

the hell out of it too."

"Deodorize it too," the choir added.

It was too much money for a sheet metal worker to spend on cleaning second-rate rugs in a third-rate row home, Michael knew. $390.60 was half a week's pay. Days out of a second-rate life. But then he thought of his wife. If it would make her happy…If only it was like it used to be so long ago before they had forgotten who the other person was. He was so tired of it all. If and if and if.

"Go for it," Michael Forbes said assertively, with a certain new set to his jaw. "It's not my life…"

"Amen!" boomed Mr. Clean. He reached a massive arm across Michael's dining room table and struck Michael Forbes a righteous high five. The high slap left him spun partially around from where he had been standing, his palm stinging delightfully, leaving Michael part of the team.

"Chuck, get your lazy black butt in gear," Mr. Clean commanded warmly. Then, "Just sign here, Michael. Make an X if you can't write…"

Then the monstrous chested laugh again. "Just kidding! Hey, we finally gonna wage war on all your damn spots! Spray the hell outta all your spills. Clean up your life!"

The big man was so genuinely delighted that Michael found himself caught up in the minister's skin-headed, powerful enthusiasm. He felt almost like a kid again.

Touchdown.

M. C. Hammer, assistant to the carpet cleaning, property owning minister, began to drag Michael's furniture away from the middle of his living room and closer to the walls. The young man moved with the bored grace of a natural athlete, hauling Michael's recliner and then, amazingly, all by himself, the long sofa out of the area to be cleaned.

Mr. Clean saw Michael Forbes looking, wondering.

"Chuck does the heavy hauling, and I does the brain work," Mr. Clean said, with the faint trace of a smile. He moved across Michael's dirty floor.

Michael watched this mountain of a man stride across his living room, down his front steps and out the front door, the two worn out heels of his white Nikes disconnected, coming apart, and slapping up against the rear of the shoes with each giant stride the big man took. He turned to help the chorus.

On his knees in his own dining room, Michael Forbes took two leaves out of his dining room table, stacked them against the wall, then began dragging the table out of the middle of this small room. The assistant saw him, moved into the dining room to help.

"Forget these old bookshelves," Michael said to his new colleague. "They're ball breakers."

Chuck Hammer agreed too easily: "Consider them 86'd."

On his hands and knees in the startlingly dirty piles of his Stainmaster carpet, Michael Forbes knew he, like all sudden converts and true believers, had been had.

Minister Clean strode back in the front door, holding his wide-¬mouthed steam vacuum head and neck, trailing yards and yards of pulsing, uncoiling, large-diameter vacuum hose that came, undoubtedly, from the dark womb of the mother Sears truck. He hummed over the outdoors blatting of the truck-mounted compressor, and he began, eagerly, to work.

"Here come da judge. Prepare to meet your maker, stains. Mr. Clean done come to town."

Strapped to his ample back, Mr. Clean wore a large green cylinder, almost like an acetylene tank, John thought. From time to time, the correspondence minister stopped to aim and pull the trigger on the tank's flexible hose that dangled waist-level by his side. He hummed and sprayed and suctioned. The man obviously enjoyed his work.

"Go ahead, dirt, make my day," this ghost-busting Dan Ackroyd, Clint Eastwood minister said from time to time. Then: "Come on, teenage spill-makers…Is that the best you can do?" Then: "Come on, compressor, don't fail me now. Come on, Chinese food. Come on home: whose your Daddy?"

M.C. Hammer, a.k.a. Chuck, moved to trail his boss, began dragging the living room furniture back to its original positions. Furniture in place, he worked effortlessly to a rhythm, raising first each leg of the sofa singly, then each leg of the recliner and placing a small, Styrofoam block under each leg's foot. When Mr. Clean had sprayed and suctioned the dining room, Chuck repositioned the table carefully, refitted the two leaves, and blocked each of the four feet with his Styrofoam squares.

Again, the big man saw Michael Forbes puzzled, wondering. So much carpet ignorance. So little blithe expectation from life.

"It's so the furniture don't stand directly on the wet carpet," he said patiently, as if explaining to a child. "You leave them foam blocks under for as long as you folks can," he intoned. "Hell, some people are so lazy they never take them out."

The Reverend was on the move, heading for the stairs, trailing big curls of vacuum hose that disappeared like a pulsing tentacle out of Michael's open front door.

Chuck brushed by—"Scuse me, Mr. Forbes"—and bounded up the stairs, no doubt to lift and float his upstairs Armada on Styrofoam blocks over waves of soon-to-be-wet carpet, Michael surmised. The two older men kept talking as the routine went on upstairs.

"Your kids good kids?" Mr. Clean asked between suctions and sprays.

Before Michael could answer, the liberator of ground-in dirt followed his own idea.

"My five boys is good boys, almost all of them grown now, but until they get to be about twenty-five, all they want to do is park their peckers in some safe home.

"They do too much thinkin' with their little heads, not their big ones, you know what I mean?" Big laughter. Spray and suction. $390, his wife. Run hard with the ball.

"Mine ain't ambitious enough to chase skirts," Michael said, half-embarrassed to have no randy son war stories to tell.

"Lord don't like idle hands," Mr. Clean said. Short spray. Bang, bang, you're dead. Long suction.

Michael felt those liquid pools of eyes searching his face.

"Don't worry, boss, ain't no sermon coming on. Just curious 'bout what you said earlier. 'Bout your wife making you do this."

Michael Forbes felt the continued religious bore of Mr. Clean's gaze. He felt almost naked, standing there on his own bedroom Stainmaster, in his own oddly distant domain.

"You always do what the little woman wants for you to do?"

It took a little too long for Michael to answer as the big man sucked dirt from his rugs. He knew the answer too well.

"She's on the rampage lately," Michael said finally. "Busts my chops over any senseless thing. Damned if I know what's going on."

"Busts your balls, huh?" Reverend Clean corrected and empathized. Always the teacher. "How long youse been married?"

"Nineteen years next week."

It was as if Mr. Clean could suck the truth right out of him as the two men slowly forged through the stained carpet piles from upstairs room to room, trailing coils of pumping hose behind like the lengths of their past lives. Chuck Hammer mingled, spraying especially bad spots here and there with his newly acquired tank and hose, changing pace now and then to float hand-me-down furniture on blocks of foam. Mostly, he stayed in the background, there when Mr. Clean beckoned, gone on to another room when the preacher seemed to want privacy.

"I lied about the carpet," Michael said meekly. The meek shall inherit…

"It's more than two and a half years old."

The big man moved in a rhythm of spray and suction, moved with a massive grace. "The Lord forgives all kinds of shit. It's all bound up in whether you mean well. Your intentions."

Short spray, long suction. Bang, bang, you're dead, dirt. Suck it all away.

"You and the missus going to celebrate next week? Nineteen years is a long time."

"Guess so."

"You ever give her any reason to cheat on you?"

Michael was only mildly surprised, "Maybe once or twice."

Mr. Clean turned off his power, put his cleaning tools aside, resting his vacuum head against the wall as if it were a world-weary traveler.

"No sermon, brother, just some friendly advice from one who knows."

Again those soulful eyes belying the menacing shaved head.

"Treat her like a queen. Get along as best you can. We all gonna be dead for a long time."

The man makes sense, Michael thought. Truth, like stains, is easy to see if you haven't walked over it, unknowingly, so many times that you've forgotten to look down.

"Got just the thing for you. Come on out to the Sears truck. Got something to show you.

Hell, we got to shut down the engine anyway."

The Reverend strode down the stairs, Nikes slapping, leaving his assistant at work above. Michael followed, meekly.

The big man warmed to the task, his mood grown expansive. "I'm trying like hell to be a man of God, you know. But I've had my falls, just like most other folk," he said.

"One time a few years ago, I had this divorcee parishioner after me. Me and the missus weren't seeing eye to eye…"

Outside, in the brilliant light of full morning, Michael's eyes were stung by the brightness. He saw tiny spots dance in his vision; the sun made him sneeze.

"Bless you…So after a few months of this mama chasing after me, droppin' hints like lint all over the place, you know, makin' it real obvious, saying things like 'after the meeting in the parish coffeehouse you can come over, Reverend, and warm up my buns,' after a few months of that shit and the Missus carping and arguing all the time, I fell into temptation. Might say I fell right into the good-lookin' divorcee's hot bear claws and cinnamon rolls. Umm, umm, I'm telling you that this woman was fi ne."

Mr. Clean had made his lumbering way to the truck, opened its sliding side door and found a small black tool box.

"Come on over here," he beckoned, waving Michael over with a swipe of his massive hand.

The color under his nails is pink, Michael thought, just like mine.

Why not? he thought. It's not my life.

"The affair was a bust," the Reverend said. "Hot and heavy for a few weeks, then cruelty and selfishness, and then I broke it off .

"Good thing too. 'Cause now me and the Missus are tighter than ever. Got past that devil, temptation. Ambition too. Had to get them out of the damn way. God done made my marriage stronger. Works in mysterious ways.

"You know it's true, Mr. Forbes. You know it ain't no lie."

"Call me Michael."

Mr. Clean fumbled around in the toolbox. His hands seemed too big to fi t easily into its confines.

"Got just the thing for you, Michael. Got just the thing for you and the Missus, for that anniversary. Make her love you all over again. Just like the beginning all over again.

"See, just before I had to break it off with the hot buns woman, before the Lord done spoke to me, I was even thinking 'bout leaving my wife for hot buns. Remember, my Missus was bitching something fierce back then. Driving me crazy outta my bald head. I thought lust was really love. It never is, you know.

It's thinking with the big head that's key, not the small one," Mr. Clean said, repeating his refrain. "The small one gets you screwed in more ways than one."

Michael Forbes thought of M.C. Hammer upstairs, unattended, in his home, in his life. Such as it was. He was surprised that he didn't care. It's not my life, he thought again, but the slogan felt oddly strange floating in his head. He imagined his wife asking tenderly, "If it's not your life, then whose?" He could see her face the first time they'd met, all those years and ground-in stains ago. They could be so good, he knew, good before something got lost.

"Yes," the big man said. "'What was lost is found. Amen.

I got this for that luscious divorcee. Was going to give it to her as a kind of sinful engagement ring back in those weeks when I fell. Changed my mind. Came to my senses through God. Come see, Michael, come closer now…"

All he had wanted to do when he awoke that morning was to read his paper. Michael Forbes hadn't bargained for this at all. The Lord works.

He leaned into the cool shade of the truck, so close to Mr. Clean that their shoulders touched. He could hear the big man's every tremendous breath.

The Reverend took the shiny loop of gold out of the grubby box, then held it higher above their heads where a shaft of bright light poured through the truck's open door and lit up the white ceiling of the Sears van.

His ring of former temptation glittered astonishingly bright in the wash of light, so fi ne and elegant against the rough and honest background of Mr. Clean's huge black hand. It was a blood-red ruby cut in an oval with many facets, ringed by small, fiery diamonds that fractured off spangles of light that

danced for a second on the white sky inside the truck.

The two men stood side by side, their eyes on the colors and the light.

"Can you believe I was that crazy out of my mind?" the Reverend wanted to know. "Three month's pay. Overtime. I could never bring myself to give it to my Missus after the fall, because for me it will always represent what I done. I ain't proud, but I ain't ashamed neither. The Lord knows. Knows it all before we think it.

"This here is just the thing for you. Get you and your Missus back on track. Give it to her on that anniversary. Make you both warm all over again. The way it should be in the fields of the Lord."

Michael's throat felt full of feathers. This whole thing was dangerous, he feared. He hated himself for asking it, but he asked anyway.

"How much?"

Michael felt a massive arm around his shoulder, smelled Old Spice and detergent there in the truck, and then the Reverend pressed the loop of gold and promise into the palm of Michael's hand.

Michael held it, cool and reassuring, with a lightness like a newborn bird in his hand. Tears smarted at his eyes, and he fought them back.

"How much?" His voice trailed off weakly, betraying him.

"Can't take less than two hundred dollars," Mr. Clean said as strongly and as surely as the fact that love drives us all.

His wife, Michael thought for a flash, what have we become? "I'll have to write you a check," he heard himself say.

"We're all brothers walking together in the fields of the Lord," the Reverend said. He closed the truck's door with a bang, conclusively, then ushered Michael up his own front steps, his soles flapping first over concrete, then soft, clean carpet as he led the way within.

"Come on, brother," he said, "we've got some more of the world's dirt to clean up."

In the Land of Buttermilk and the Drakesbad Moon

Part Two

So the afternoon grew hotter, and the light through the tree canopy came first straight down and then at a western angle, over by Mt. Lassen with its fingers of snow still holding in August and its severe gray slope, and the bluest of sky dome peeking between the trees to the earth the two hiked on, borrowed from the animals, borrowed from the natives peoples and then someone else's ancestors. A golden eagle sailed the clean blue dome of sky above and then was gone. The last best place.

Shared afternoon grew into slanting sun, and it was time to hike out even though the trees and the birds and the sun and the sky called out to them to never leave, to never grow old, to never die, to always have their faces kissed by this very sun, this very air so pure that is was nothing and everything both at the same time. They wanted, like the trophy trout, no doubt, to hide in the shadows, apart from time, immortals: to just be, if anything, a part, a tiny part, of the big nexus of earth life.

But Cindy was coming into camp, up from the south near the gold country, up the Feather River canyon, and she was driving the Thunderbird with it Sears tire pattern, for Cindy hadn't gone to Colorado with her horses and dogs yet to find her bliss, and was loved like the late sunlight on their faces with their stubble of beards and bright eyes…Imaginations the size of spreading, upcoming sunsets and moonrises.

And she would be driving into Drakesbad camp sometime that very evening, depending upon the vagaries of a four hour drive combined with free will, and she would be Thunderbirding in Leonice's borrowed car right up the very, selfsame Chester Warner Valley Road to the camp road that James H. and James A. had to weary march now back to camp, could they even find it in the coming dark. And, of course, in the now-fading light, there were eight more miles of chances to get delightfully lost before the legendary road to camp.

And so they fought out the natural, pristine miles as peacefully as a baby sleeps after two years of colic and then a solid night's sleep. Neither of them ever complained, and there was precious little talk, except some mild concern about missing one of the chef's great, gourmet dinners in the wild. And a nighthawk called to them as the sun fell yellow-burgundy and orange and crimson and tall tree-obscured to the west, dropping right into Mt. Lassen's exploded caldera crater like an orange sherbet scoop on a white sugar glazed volcanic cone. All such paintings should be framed by pines, they thought.

There was a little soldiers-returning home from the front talk about spouses left behind, about how

James H.'s wife Leonice wouldn't be at all mad, would only be concerned about keeping his dinner warm, keeping good things as they were, how that concern would be genuine and not because James H., being a successful doctor, was wealthier than his English teaching in the east son, some talk about James Andrew's life. There was a laugh or two or three, shared, at no one's real expense, and then the flashlights came on and there was the silence of soldiers fighting just to be here now and only half welcoming the return from a perfect alpine day now morphed to perfect pre-moonlight.

And then some white and pink cottages loomed that were only two miles from the Chester dirt and gravel road, viewed ghostlike and yellow by flashlight in the dark trees and night bird song of doves and owls and red-winged blackbird. And then the road…

And then there were the T-bird's tire tracks in the dust and rock under an emerging bone-white full moon that made the Freeman men put out their flashlights and rejoice about the prospect first of meeting up with Cindy and then catching a ride those last miles-and then, after careful consideration of the fact that her tire tracks on the road meant that she had **already** come through, the other overriding joy that she would be there, safely, when all were reunited…And then…

Well, those last miles were long but magic, backlit by moon over alpine paradise, shadowy and with moving night creatures in the brush in the literal, but clear as the man in that moon's face in the figurative memory. Buttermilk the bear must have slept somewhere nearby, all those years ago, just as she ambles on even now, the legendary and true blonde highlighted brown, primordial mother bear. And when the Freeman men saw the welcome kerosene lanterns in the windows of the Drakesbad cabins, the duplex, the annex, the kitchen, the Sifford's lodge, all awash in midnight moonlight, just when they could forced march no further, just as when they were just as tired as with the aborted climb of Mt. Shasta's north face after a similar eight mile unplanned diversion, all impossibly uphill, just as it should be, with Drakesbad dinners warmed up and waiting and red wine and stories, there on the very porch where a distant dark-o-clock breakfast seemed another lifetime ago and yet also simultaneous…

There was and is their Patria. In the land of sleeping mother Buttermilk bear and of their place in history and in the non-English language of natural world and sensory human Braille.

And all's well that ends well. And legends and days will grow deep and prosper. All without Latin or cities or cell phone texting or T.V. And Bobby Sands, the I.R.A. hunger striker, was right: "the best revenge in life is the happy laughter of your grandchildren."…But Bobby forgot to mention telling Irish fish stories. And so you and I will tell fish stories and adventure true. And we will live forever in the babbling and inarticulate riff s of Drakesbad creek water rushing over stone. In the double reflection of white-capped Mt. Lassen in volcanic carved cistern and tarn lake water; in the sweet pine-needled shadow-song of breeze; in the cloudless, azure sky, we will tell our Freeman legends true.

Biblical Time Out of Mind—Maps, Myths and Memories by **James A. Freeman** and **Tom Gage** with Cune Press (www.cunepress.com / www.cunepress.info) ISBN 9781614571353 ($21,pbk.) is an exciting world **Peace** plan; "is a book of scholarship and vision, one that enlightens and empowers. It leads us to reflect on the past, to live wisely in the present, and to hope for the future"—Dr. Christopher Bursk, author of *The Improbable Swervings of Atoms* and many others

Help the authors spread their non-fiction Peace plan by buying a copy of this important book, by sharing it, and by taking it to heart.

Call with any questions Jim Freeman 215-801-0433 (cell) 215-968-1991 (home landline) 215-968-8155 (private line at college with voicemail)

James.freeman@bucks.edu

jamesandrewfree@gmail.com

Printed in the United States
by Baker & Taylor Publisher Services